THE ARTIST'S SOURCE BOOK

80 *Watercolor Painting References*

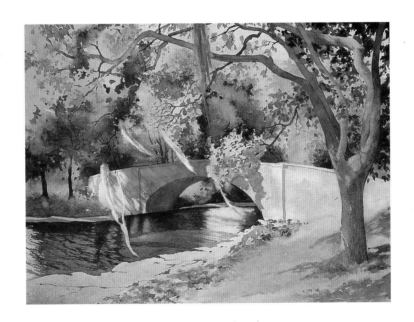

Walter Foster Publishing, Inc.
23062 La Cadena Drive
Laguna Hills, California 92653
www.walterfoster.com

CONTENTS

INTRODUCTION TO WATERCOLOR

Watercolor is a fascinating and dynamic medium that lends itself to painting spontaneously. Because of its versatility, you can achieve a wide variety of rich, expressive results. For example, you can build up vibrant colors by glazing or you can paint with thin, translucent washes. You can also create a range of effects using simple materials like table salt, sponges, and toothbrushes. Watercolor paint is easier to use than oil paint is because watercolor requires no special solvents or mediums. And because you can find water almost anywhere, watercolor is the ideal medium for painting outdoors and on the go.

This book provides 80 different watercolor subjects that you can re-create, in addition to line-drawing templates for most of subjects. The templates (along with the transfer paper located in the pocket at the back of the book) make it easy to block in the basic outline of your subjects on the painting surface, without having to first draw them freehand. In addition, the color samples with mixing formulas help simplify the color-matching process. These painting aids paired with inspiring images will provide an unforgettable artistic experience!

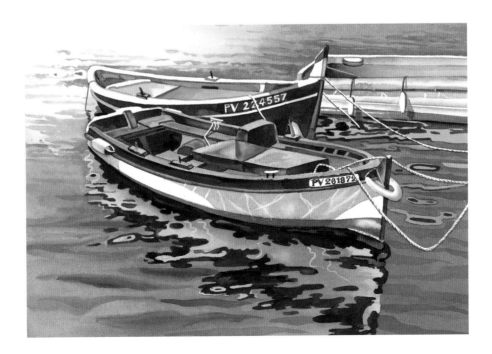

TOOLS & MATERIALS

Even though you'll find a seemingly endless selection of paints, brushes, papers, and other watercolor materials at your local art supply store, don't feel as though you need to stock up on every imaginable offering. The materials featured on the following pages cover the basic supplies you will need to get started; you can always expand your collection as you develop your skills and personal painting style. You can purchase a limited number of supplies, but always choose the highest-quality materials you can afford at the time. They'll last longer and provide better results than their less-expensive counterparts. To learn more about watercolor tools and materials, refer to *Watercolor & Acrylic Materials* by William F. Powell in Walter Foster's Artist's Library series.

PURCHASING PAINTS

Watercolor paints are available in tubes, pans, and cakes. Most artists prefer tube watercolor because it is already moist, which makes it easier to use. Tubes also allow you to squeeze out the desired amount of color quickly and easily. Alternatively, pan and cake paints are small and light, making them convenient for travel. All watercolor paints come in two grades: "artist's grade" and "student's grade." Be sure to always select artist's grade, which are made with purer pigments that make richer and longer-lasting colors.

◀ Using Tubes Tube colors are moist and are great for painting large areas and washes because you have more control over the flow of paint. You can also obtain pan watercolor paints, which are semi-dry blocks of color that are often sold in sets.

Limited Palette

A *limited palette* comprises a relatively small range of colors that enables you to mix a number of other colors. The following basic palette is needed in order to re-create the paintings in this book:

1	2	3	4	5
6	7	8	9	10
11	12	13		

1. Ultramarine blue
2. Cerulean blue
3. Payne's gray
4. Sap green
5. Hooker's green
6. Lemon yellow
7. Indian yellow
8. Naples yellow
9. Blue-violet
10. Burnt sienna
11. Burnt umber
12. Crimson
13. Magenta

BUYING BRUSHES

Watercolor brushes are categorized by size, shape, and hair type. Brush *size* is indicated either by a measurement (for example, in fractions of inches) or by a number, such as #2. The numbering system varies by brand. For example, although a #2 brush is usually very small, the length and width of the bristles may differ slightly by manufacturer. In general, the smaller the number, the smaller the brush. Brush *shape,* such as round, flat, or specialty, determines the type of stroke you create. Each shape is best suited to a particular task; for example, a flat shape works well for laying in washes, whereas a small round shape is good for detail work. Hair *types* are either natural or synthetic: Natural-hair brushes have more spring (the way the brush quickly bounces back into shape after each stroke) and absorbency, whereas synthetic brushes are less expensive and often last longer. To protect your brushes, always rinse well after each use and reshape the bristles before laying them flat to dry.

▶ Distinguishing Between Brushes A flexible flat brush is great for painting thick bands of color; a small round brush is ideal for detail work; and a liner or rigger brush is perfect for painting very fine lines.

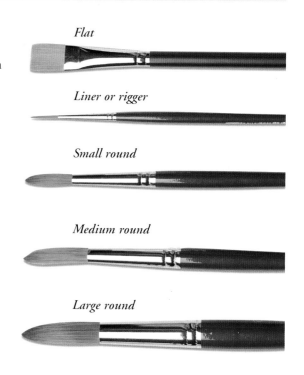

Flat

Liner or rigger

Small round

Medium round

Large round

SELECTING SUPPORTS

You can choose to paint on different surfaces (called "supports"), such as illustration board or Bristol board, but most watercolorists prefer to paint on paper. *Hot-press* paper is smooth; *cold-press* paper has a medium texture; and rough paper has the most texture. Smooth papers are more absorbent than watercolor boards and will make your painting appear softer, whereas rougher textures lend themselves well to more tactile outdoor scenes. Paper is also categorized by weight, designated in pounds: The higher the number, the heavier the paper. Medium-weight 140-lb paper is popular and a good choice for beginners, but a heavier paper, such as 260- or 300-lb, won't buckle under multiple layers of paint.

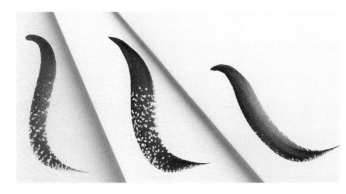

▲ **Understanding Paper Textures** Here are samples of the way watercolor appears on hot-press (far right), cold-press (center), and rough (far left) paper textures.

CHOOSING A PALETTE

Mixing palettes are available in glass, ceramic, plastic, and metal. All can be washed with soap and water, but glass and ceramic palettes are heavier and generally more expensive. Palettes also come in many shapes, but they all contain individual color wells and at least one area for mixing color. Choose a palette with multiple wells for holding a variety of colors, and a large, flat mixing area to accommodate washes.

◄ **Selecting a Style** Whether you choose a round-, oval-, or square-shaped palette, make sure your widest brush will fit into the wells.

GATHERING EXTRAS

A sketchpad, pencil, and eraser are great for making quick sketches and blocking in compositions. Rags, paper towels, and extra water containers are ideal for making cleanup convenient and rinsing brushes. A spray bottle comes in handy for moistening your paints or paper. And a toothbrush, plastic wrap, tissues, salt, masking tape, and sea sponges are perfect for creating a variety of special effects.

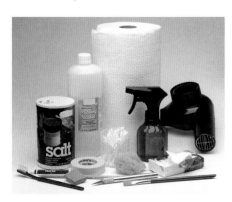

▲ **Adding to the Basics** Additional supplies may include masking fluid *(frisket)*, a craft knife, or a hair dryer to speed up drying time. Also consider a sun hat and folding stool for outdoor painting.

FINDING A WORKSPACE

Your personal workspace can be as elaborate or as simple as you choose, but two elements are always essential: comfort and good lighting (natural light is best). Try to work in an environment with few distractions, and include a supportive chair. When you're comfortable, you'll be able to paint for longer and more enjoyable periods of time. When selecting a drawing board, look for versatility and functionality. Choose a smooth board that can be adjusted or propped up easily. Many boards have carrying handles and clips for holding your paper in place. If you prefer to use an easel, look for a tabletop version so you can sit down while you paint.

COLOR THEORY & MIXING

Understanding color is one of the most important aspects of painting in any medium. The choices you make influence the viewer's emotional response and set a mood for the painting. Color determines whether your painting is seen as vibrant and emotional, cool and refreshing, or warm and inviting. Having a basic knowledge of color relationships is essential in helping you add interest and harmony to your paintings.

COLOR BASICS

Before you begin painting, it is helpful to become familiar with some basic color terms. The three *primary* colors (red, yellow, and blue) cannot be created by combining any other colors; all other colors are derived from these three. Mixing two primary colors together makes a *secondary* color (purple, green, and orange). *Tertiary* colors (such as red-orange and red-purple) are those that result from mixing a primary color with a secondary color.

GLAZING AND LAYERING COLOR

The transparent nature of watercolor makes it difficult to achieve dark colors with just one application. This is because the white of the paper always shows through to some degree. Watercolorists use a technique called *glazing* to build up darker colors and to mix colors visually on paper. Glazing is done by applying a thin layer of paint over an existing (dry) color. Because some colors are more transparent than others, try experimenting with your palette to see the effects of various glazes.

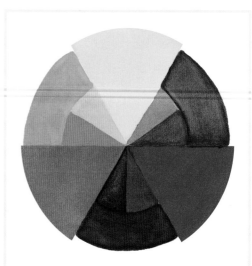

Using a Color Wheel A color wheel provides a helpful visual reference for studying the color relationships. *Complementary* colors are any two colors that lie directly across from each other on the color wheel; groups of adjacent color are *analogous*.

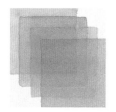 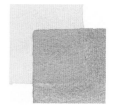

Glazing to Darken Color When glazing one color over another color, be sure to let the first layer dry before painting over it, as you don't want to disturb the underlying color.

Layering to Mix Colors You can alter the underlying color by painting over it, but you can't completely mask it with the new color (as more opaque paints, like oil and acrylic, would).

CREATING VALUES

Value is the relative lightness or darkness of a color (or of black), and it's the variations in value that create the illusion of depth and form in a painting. You can produce lighter values by adding more water (the lightest value being the white of the paper), and you can create darker values by building up additional applications of paint. Some of the color formulas in this book (see "Color Formulas" on page 7) call for adding more water. These color samples were created with the same mixture of paints as another sample in the same painting; to get the specific color to match, you will need to add more water to create a lighter color.

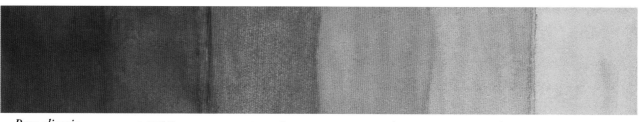

| *Pure alizarin crimson* | *+ water* | *+ more water* | *+ more water* | *+ more water* | *+ more water* |

CARING FOR YOUR PAINTBRUSHES

Brushes must be thoroughly cleaned after each use—if they are cleaned properly and often, they'll last a long time. Never let a brush sit with paint in it, even during a painting session.

First rinse the brush in cool water; then use paper towels to wipe off as much paint as possible. (Always pull straight away from the bristles—never pull sideways.) Then, using a very mild soap or shampoo and cool water, gently rub the bristles in the palm of your hand to loosen any remaining paint. Rinse thoroughly, reshape the bristles with your fingers, and lay the brush flat on a paper towel to dry.

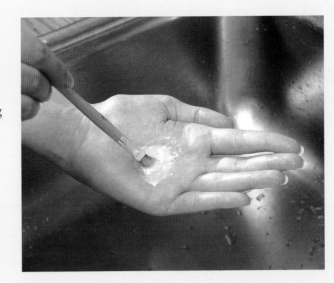

COLOR FORMULAS

To help you re-create the paintings in this book, many of the paintings are accompanied by *color mixes*—visual samples of paint that show some of the colors used for the painting—as well as the *formulas,* or the proportions of paint that make up each mix; for example, one part sap green + one dot lemon yellow. The formulas are approximate and are based on the limited palette listed on page 4. While every effort has been made to match the colors of the printed paintings, there are some colors that are impossible to match exactly in print; but by following the formulas that accompany the color samples, you should be able to achieve colors that closely match those of the printed paintings. Keep in mind that each brand of paint is different and that colors may vary in intensity.

MEASURING

Squeeze out the paint in uniform widths and lengths according to the color mixture formulas. It doesn't matter what size you use as a "part" as long as each part is equal in size to keep the proportions correct.

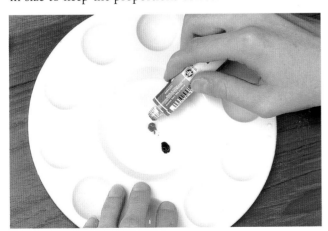

Measuring "Parts" Watercolor paint goes a long way, so squeeze out just a small amount of paint for each "part."

Some mixtures require a very small amount of a color, which is referred to as a "dot." A dot is the amount of color that comes out when you gently squeeze the tube while touching the opening of the paint tube flat on the palette, creating a round "dot" of paint. Remember that a "dot" should be much smaller than $1/2$ part.

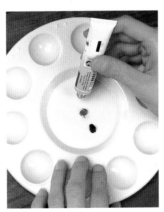 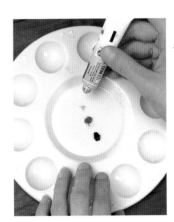

Step 1 To make a "dot," touch the opening of the paint tube flat on the palette.

Step 2 Then squeeze out just a small, flat "dot" of paint, as shown above.

MIXING

After measuring the paints, use your brush to gently blend the colors together; then add enough water to reach the proper dilution as shown in the color sample. (See page 6 for more information on adding water to your color mixtures.) Note: When working with watercolor paint, it is important to always wet the brush before dipping it into the paint. A wet brush allows the paint to slide off the brush, making the paint easier to control and manipulate.

PAINTING TECHNIQUES

Every artist has his or her own painting technique—the way you manipulate your brush is as unique as your signature. But there are a range of techniques that are especially helpful for painting in watercolor, from laying down washes of color to preserving white areas of your painting and correcting mistakes. By using the simple methods featured on these two pages, you will be able to create a range of fascinating textures—from skies and water to rocks and sand—and even produce special effects using household objects. Once you understand the way watercolor works, and the way it works for you, you'll be amazed at how easy it is to master a variety of painting techniques.

PAINTING A FLAT WASH

Painting a *flat* wash is a simple way to cover a large area with even, diluted color for an *underpainting*—the initial layer of color that influences all successive layers of color—or for backgrounds. A flat wash can be laid in on wet or dry paper, or a combination of the two for varied results. For a flat wash, load your brush with color before each stroke to maintain the same depth of color overall.

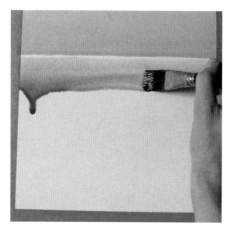

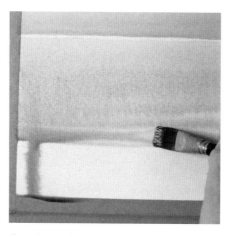

Step 1 Begin by tilting your painting surface to an upright position. Load your brush with color, and apply a horizontal stroke all the way across the top of the support.

Step 2 Load your brush again to make another overlapping horizontal stroke, picking up the drips and runs from the previous stroke. Always begin each stroke from the same side of the paper.

Step 3 Continue loading your brush and overlapping your strokes, always working in the same direction. (Any streaks should even out as the paint dries.)

PAINTING A GRADED WASH

A *graded* wash starts with a dark value of a color and becomes gradually lighter. This type of wash is ideal for painting clear skies and realistic water. It's easier to paint a graded wash on dry paper because you have more control over the flow of the paint and your lines will be neater and more even.

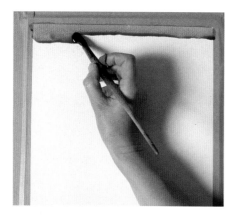

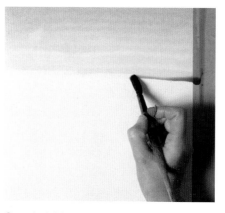

Step 1 Tilt your support to an upright position and pull a horizontal band of pure (undiluted) color across the top of the painting surface.

Step 2 Add more water to your brush and apply another horizontal stroke, slightly overlapping the first. Work your way down the support, adding water (but not color) before each new stroke.

Step 3 If necessary, go back in with more water or color to smooth the gradation and create the desired effect. Gently stroke back and forth to blend the color, if you choose.

SAVING WHITES

You can "save" the white and light values of your paper either by painting around the white areas of your subject or by applying a mask to protect the paper from subsequent applications of color. Watercolor artists use various methods of masking, including liquid frisket (also called "masking fluid") and artist's tape, which leaves no sticky residue.

Using Frisket Paint the frisket over the areas you want to remain white and let it dry before applying more color. When dry, remove the frisket by gently rubbing with your finger or a rubber eraser.

Masking with Tape Use artist's tape to mask the edges of the painting area. When the tape is removed, the neat, white edge gives you a good idea of what the painting will look like matted.

Lifting Out To lighten the tone of an area, remove wet paint by blotting it with a cloth or paper towel. To remove dry paint, wet your brush or a cloth and lightly scrub away the desired paint.

WORKING WITH SPECIAL EFFECTS

Special effects in watercolor can add realism, harmony, and visual interest to your paintings. You can use sponges, salt, and other household items to create realistic textures for rocks or sand, or you can manipulate your brushstrokes and use varying amounts of paint to produce exciting visual patterns. Each one of these specialized techniques produces a unique and exciting result, so be sure to familiarize yourself with them all!

Painting Wet into Wet Paint wet color onto a wet support or onto another layer of wet color. This technique will produce soft edges and smooth blends.

Painting Wet on Dry Paint wet color onto a dry surface or an already dry layer of color to increase your control over the spread and bleed of color.

Drybrushing Dip the tip of your brush in paint and blot it to remove the excess moisture; then stroke over dry paper or dry color to create rough, broken strokes.

Spattering Load a toothbrush with thick paint and run your finger over the bristles, creating a fine spatter of paint for grainy textures.

Sponging Load a sponge and dab on paint to add depth and texture to your paintings. Apply firmer pressure for more solid textures.

Using Salt Sprinkle salt over wet paint; then brush it away when the paint is dry to produce a mottled texture where the salt has absorbed the moisture.

TRANSFERRING A SKETCH

When working with a more complicated subject, it's often helpful to first work out the composition on a separate sheet of paper and then transfer it to your painting surface; this lets you quickly establish the composition and proportions on your support. There are two popular ways of transferring a sketch: using transfer paper and using the grid method, both of which are described in detail over the next two pages. The templates provided in this book simplify the process, allowing you to easily transfer the lines of the sketches without having to draw them. As a cross-reference, the page number for each template is located beneath the corresponding painting within the book, and the page number for each painting also accompanies the corresponding template.

USING TRANSFER PAPER

The simplest way to transfer a sketch is to use *transfer paper*—thin sheets of paper that are coated on one side with an even application of graphite. To transfer a sketch to your support, place the transfer paper (found in the pocket at the back of this book) onto your painting surface, graphite-side down. Use masking tape or artist's tape to hold the transfer paper in place on your support. Then place the template on top of the transfer paper (you may need to enlarge or reduce the template on a photocopier to fit your support) and lightly trace over the lines with a pencil or a sharp object that won't leave an ink or pencil mark, such as a stylus or the pointed end of the handle of a thin paintbrush. Before you begin, test a small corner of the transfer paper to learn how much pressure to place on the pencil to achieve the desired line weight. You can use the transfer paper in this book several times, as you would carbon paper. You can purchase additional sheets of transfer paper at your local art supply store, or you can even make your own (see "Making Your Own Transfer Paper" below).

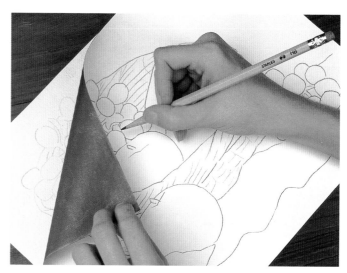

Checking Your Lines While tracing the lines of the template, occasionally lift the corner of the template (and the transfer paper) to make sure that the lines that have transferred to your painting surface aren't too light or too dark.

MAKING YOUR OWN TRANSFER PAPER

Step 1 When you need more transfer paper, you easily can make your own. First make a photocopy of the desired template (reducing it or enlarging it as needed). Next use a pencil to completely cover the back of the photocopy with graphite, pressing down firmly to create an even layer of coverage.

Step 2 Now turn the photocopy right-side up so that the graphite is against the painting surface; secure it in place; and lightly trace the lines of the sketch to transfer them. Always use light pressure when tracing the sketch; pressing too hard may leave permanent indentations on your support.

Step 3 Check underneath the photocopy occasionally to make sure you're not pressing too hard, thereby creating too dark of a line on your painting surface. If the transferred sketch is too dark, the translucent watercolor paint won't cover it.

USING THE GRID METHOD

Another useful tool for transferring a sketch is the grid method. If your template is too large or too small for the painting surface and you don't have access to a photocopier, you can use this technique to transfer your sketch while enlarging or reducing it at the same time. The grid method involves dividing the template into a series of squares (a grid pattern) and then creating corresponding squares on your watercolor paper. (Both the template and the watercolor paper must have the exact same number of squares; so, even if they're not the same size, the original image and the watercolor paper must have the same proportions.) Once you have created the grids, simply draw what you see in each square of the template in each square of the watercolor paper. Draw in one square at a time until you have filled in all the squares. Note: A one-inch square is a good size to start with. When the squares are larger, more freehand drawing is required; when the squares are smaller, more detail is required. Study the step-by-step example below to become familiar with the grid method; then try it on your own!

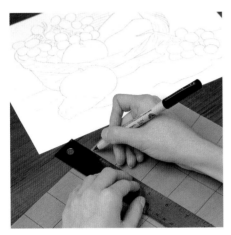

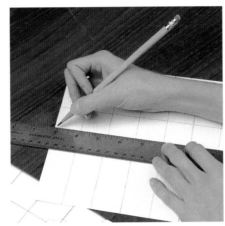

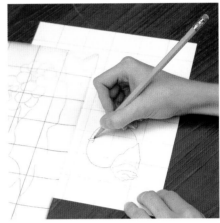

Step 1 Trim a piece of tracing paper to fit the template. (If there is no template, trim it to fit the printed painting.) Then use a fine-tip black marker and a ruler to draw a grid of perfect squares on the tracing paper. You can make the squares any size you'd like; in general, the smaller the squares, the more accurate and detailed your sketch will be. (You might want to use a calculator to determine what size the squares need to be to perfectly fit the paper.)

Step 2 Using a pencil and very light pressure, draw a grid on your watercolor paper with the exact same number of rows and columns (and squares) as the one you made in step 1. Note: If the original image is smaller than your watercolor paper, the squares on the watercolor paper will have to be larger than those on the tracing paper; if the original image is larger than your paper, the squares on the watercolor paper will have to be smaller.

Step 3 Once the grid on your watercolor paper is established, you can begin transferring the drawing to the watercolor paper. First tape the tracing paper grid from step 1 over the template (or printed painting) to hold it in place. (You should be able to see the image through the tracing paper.) Then, using a pencil and light pressure, copy the lines you see in each square of the tracing paper grid into the corresponding squares on your watercolor paper.

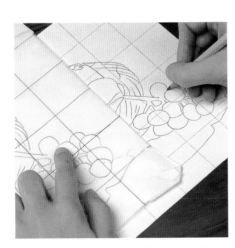

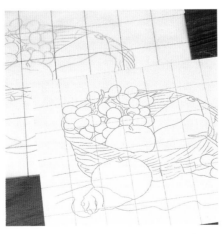

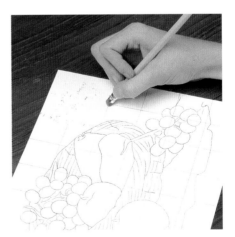

Step 4 As you copy the lines in each square, pay particular attention to where the lines touch the sides of the square. If you make a mistake, simply erase the line and redraw it.

Step 5 Once you have transferred the lines in every square, the image on your painting surface is complete. Compare your drawing to the original image and make any necessary adjustments.

Step 6 When you're happy with your drawing, carefully erase the grid lines, being cautious not to smudge the lines you want to keep. Then you're ready to start painting!

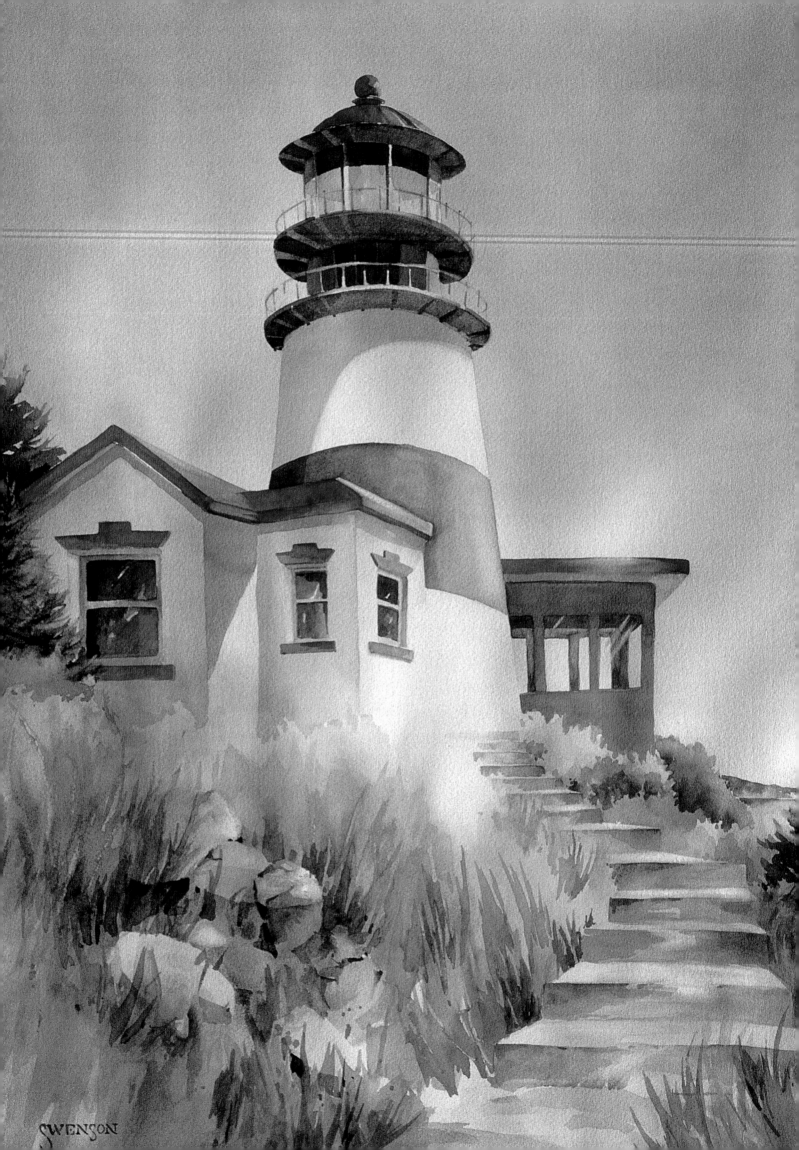

CHAPTER 1

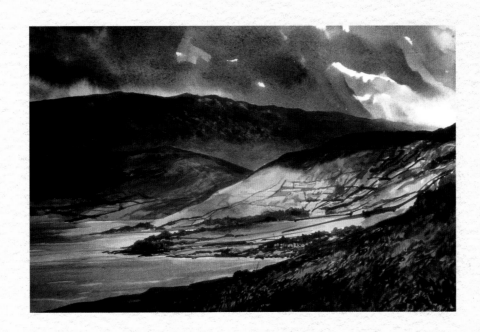

Landscapes

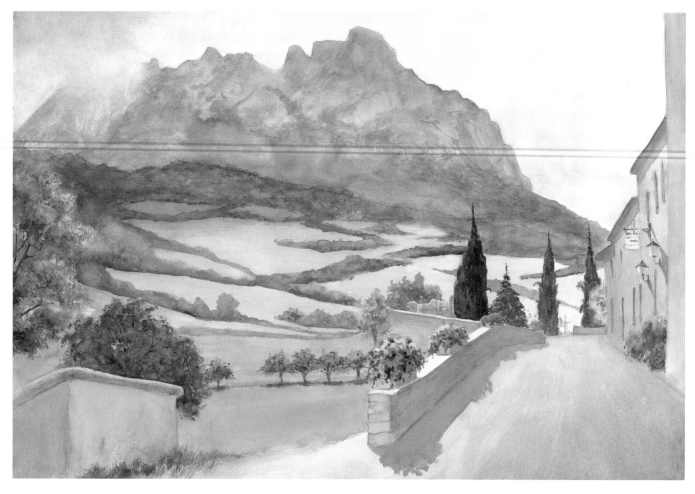

BARBARA FUDURICH *(See template on page 90.)*

Structure detail

Foliage and grass detail

Structure rim

1 part Naples yellow +
1 dot crimson +
1 dot burnt umber

Structure midtones

1 part Naples yellow +
1 dot blue-violet +
1 dot magenta

Structure shadows

1 part Naples yellow +
1 dot blue-violet +
1 dot ultramarine blue

Grass

1 part lemon yellow +
1 dot cerulean blue

Foliage darks

2 parts ultramarine blue +
2 parts sap green +
1 part burnt umber

Sky

1 part Naples yellow +
1 part cerulean blue +
1 dot crimson +
1 dot ultramarine blue

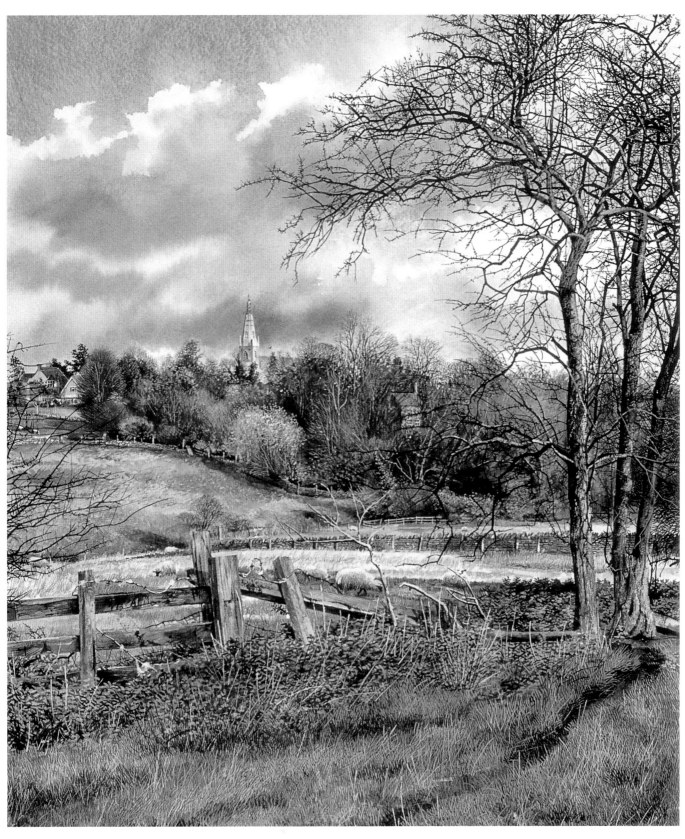

MARTIN TAYLOR

Sky	*Tree yellow*	*Tree purple*	*Tree brown*	*Grass lights*	*Grass darks*
1 part ultramarine blue + 1 dot Naples yellow + 1 dot magenta	1 part lemon yellow + 1 dot burnt sienna	1 part burnt sienna + 1 part cerulean blue + 1 part magenta	2 parts burnt sienna + 2 parts Naples yellow + 1 dot ultramarine blue	2 parts Naples yellow + 1 dot sap green	2 parts ultramarine blue + 2 parts sap green + 1 part burnt umber

Landscapes

Leaf lights

3 parts lemon yellow +
1 part sap green

Leaf darks

2 parts sap green +
1 part cerulean blue +
1 part crimson

Purple flowers

2 parts crimson +
1 part ultramarine blue

Red flowers

1 part crimson +
1 dot lemon yellow

Foreground darks

1 part burnt sienna +
1 dot ultramarine blue

Tree darks

2 parts burnt sienna +
1 part ultramarine blue

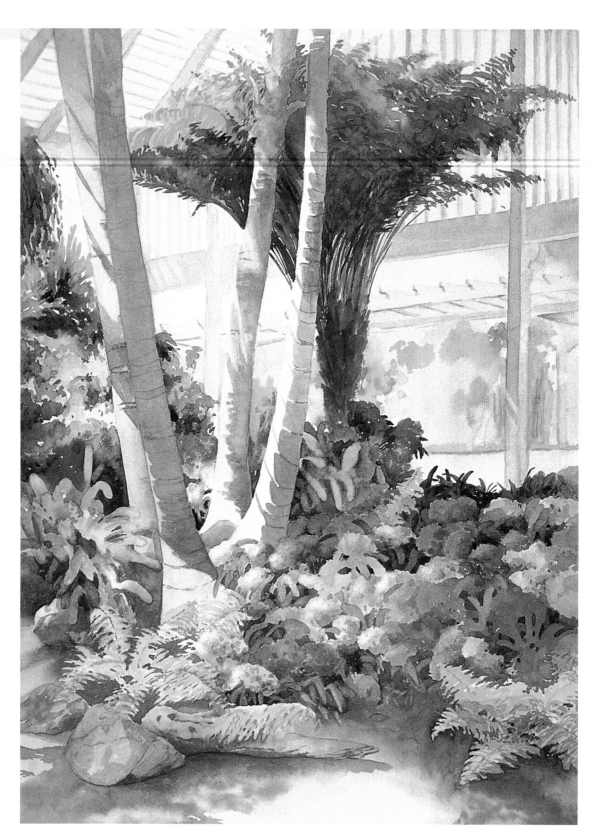

BARBARA FUDURICH *(See template on page 91.)*

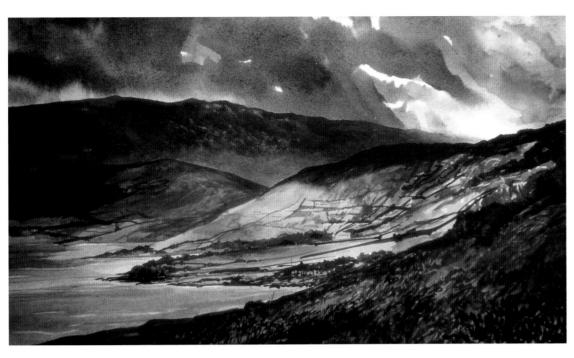

BRYN CRAIG *(See template on page 92.)*

Hill lights

Naples yellow

Hill midtones

3 parts crimson +
1 part sap green

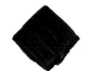

Hill darks

2 parts crimson +
2 parts ultramarine blue +
1 part sap green

Foreground red

2 parts burnt sienna +
1 part crimson +
1 dot cerulean blue

Water

1 part ultramarine blue +
1 dot sap green

Sky darks

1 part ultramarine blue +
1 dot crimson +
1 dot sap green

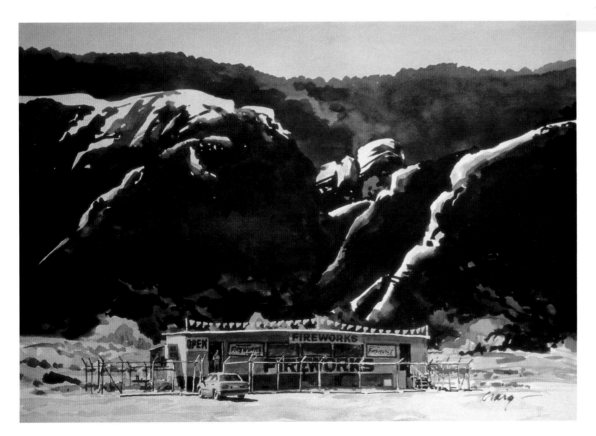

BRYN CRAIG *(See template on page 92.)*

Foliage lights

1 part lemon yellow +
1 dot cerulean blue

Foliage midtones

1 part cerulean blue +
1 part Naples yellow +
1 part Hooker's green

Foliage darks

1 part Hooker's green +
1 part crimson +
1 part ultramarine blue

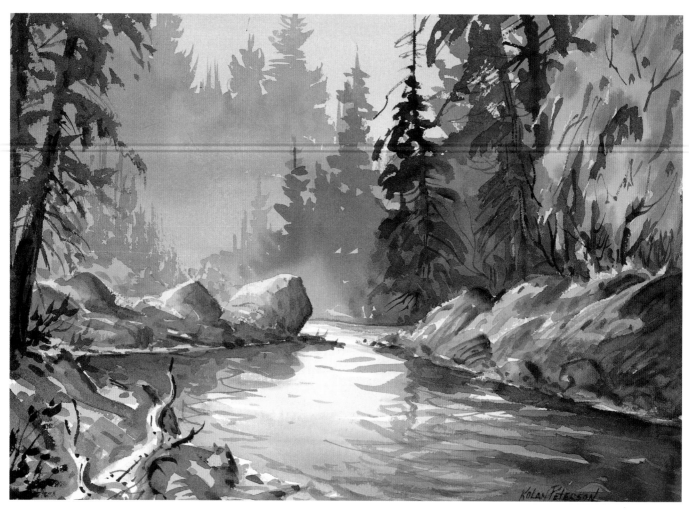

KOLAN PETERSON

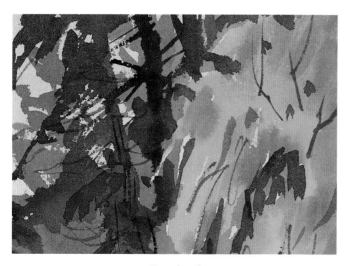

Tree detail

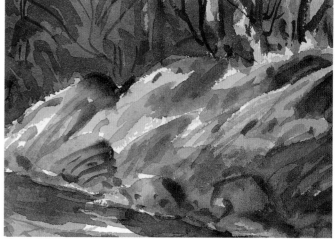

Rock detail

Tree lights

3 parts lemon yellow +
1 dot burnt umber

Tree darks

1 part blue-violet +
1 part cerulean blue +
1 part sap green +
1 part ultramarine blue

Tree silhouettes

1 part ultramarine blue +
1 part cerulean blue +
1 dot sap green

Rock lights

1 part Naples yellow +
1 dot crimson

Rock midtones

1 part Naples yellow +
1 part burnt sienna

Rock darks

2 parts ultramarine blue +
1 part burnt umber

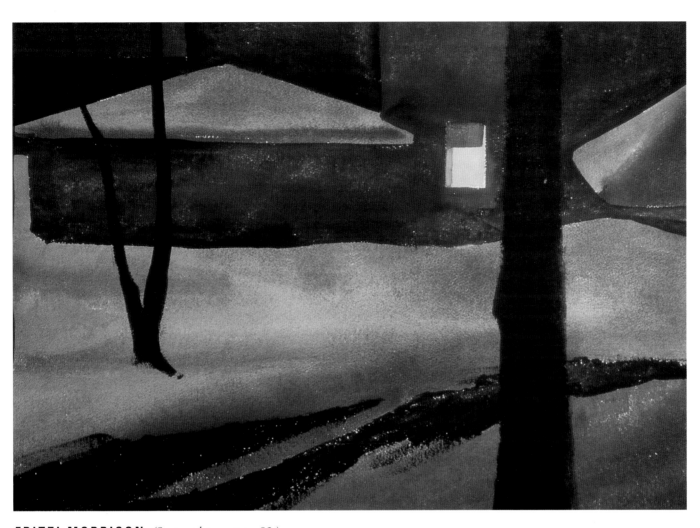

FRITZI MORRISON *(See template on page 93.)*

Snow lights	*Snow darks*	*Building*	*Window*	*Trees*	*Sky*
2 parts Naples yellow + 1 part magenta + 1 dot ultramarine blue	2 parts ultramarine blue + 1 part magenta + 1 part cerulean blue + 1 dot Naples yellow	1 part burnt sienna + 1 dot ultramarine blue	1 part lemon yellow + 1 dot Indian yellow	1 part ultramarine blue + 1 part Indian yellow + 1 dot blue-violet	1 part burnt sienna + 1 part ultramarine blue

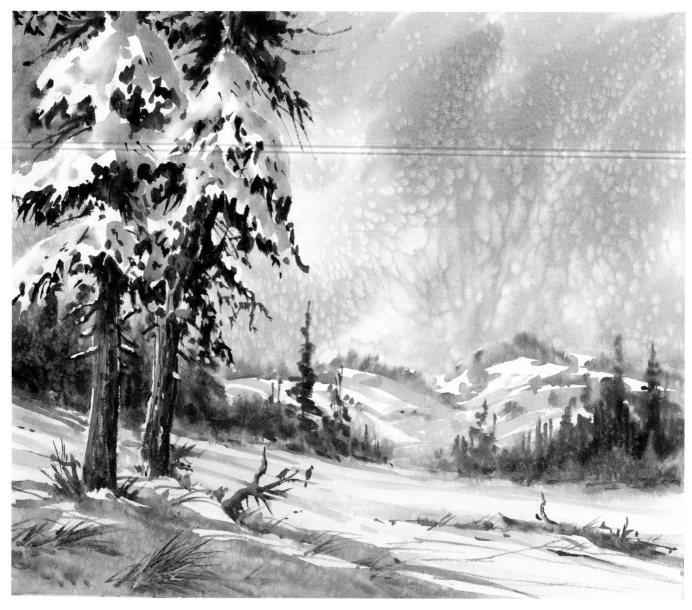

KOLAN PETERSON

Snow shadow lights	*Snow shadow midtones*	*Tree trunk darks*	*Tree trunk lights*	*Leaf midtones*	*Leaf shadows*
1 part lemon yellow + 1 dot burnt umber	3 parts ultramarine blue + 1 part cerulean blue + 1 dot Naples yellow + 1 dot magenta	1 part burnt umber + 1 part burnt sienna + 1 dot Naples yellow	1 part burnt umber + 1 part burnt sienna + 1 dot Naples yellow + more water	1¼ parts crimson + 1 part sap green + 1 part ultramarine blue + 1 dot lemon yellow	2 parts ultramarine blue + 2 parts sap green + 1 part burnt umber

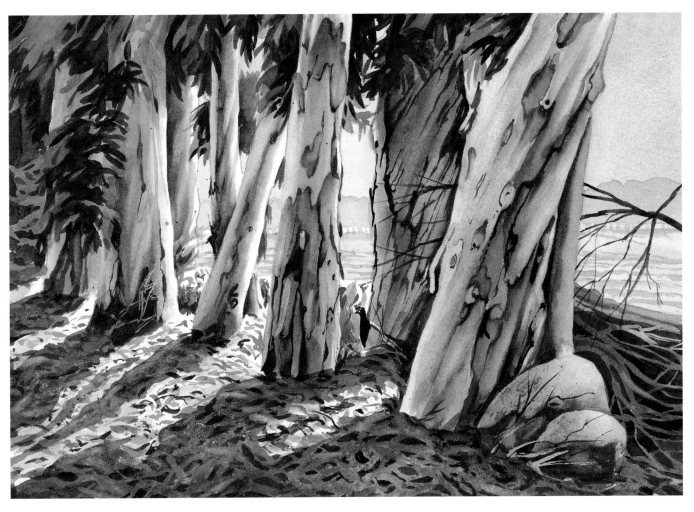

GERI MEDWAY *(See template on page 94.)*

Tree cast shadow detail

Shadow pink

1½ parts magenta +
1 part ultramarine blue

Shadow light blue

4 parts cerulean blue +
1 part lemon yellow

Shadow dark blue

3 parts ultramarine blue +
2 parts cerulean blue +
½ part magenta +
1 dot lemon yellow

Leaf lights

1 part ultramarine blue +
1 part crimson +
1 part sap green

Leaf midtones

1½ parts sap green +
1 part ultramarine blue

Leaf darks

2 parts sap green +
1 part crimson

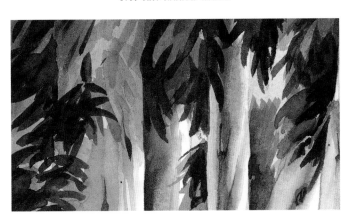

Leaf detail

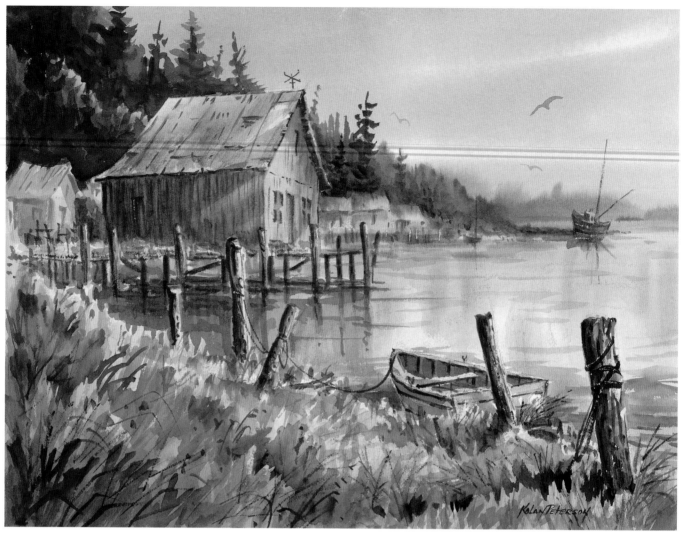

KOLAN PETERSON *(See template on page 95.)*

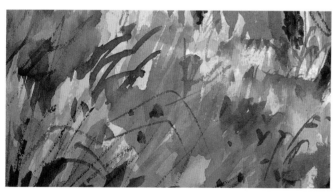

Grass detail

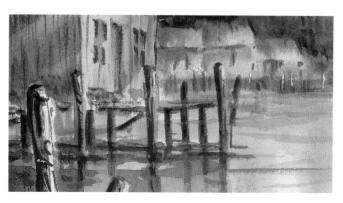

Dock detail

Grass green

1 part ultramarine blue +
1 part sap green +
1 dot Naples yellow

Grass orange

1 part burnt sienna +
1 dot Naples yellow

Grass yellow

Lemon yellow

Dock midtones

1 part burnt umber +
1 part burnt sienna +
1 part Payne's gray

Water lights

1 part cerulean blue +
1 part ultramarine blue +
1 dot Naples yellow +
1 dot Payne's gray

Water darks

1 part ultramarine blue +
1 dot cerulean blue +
1 dot lemon yellow

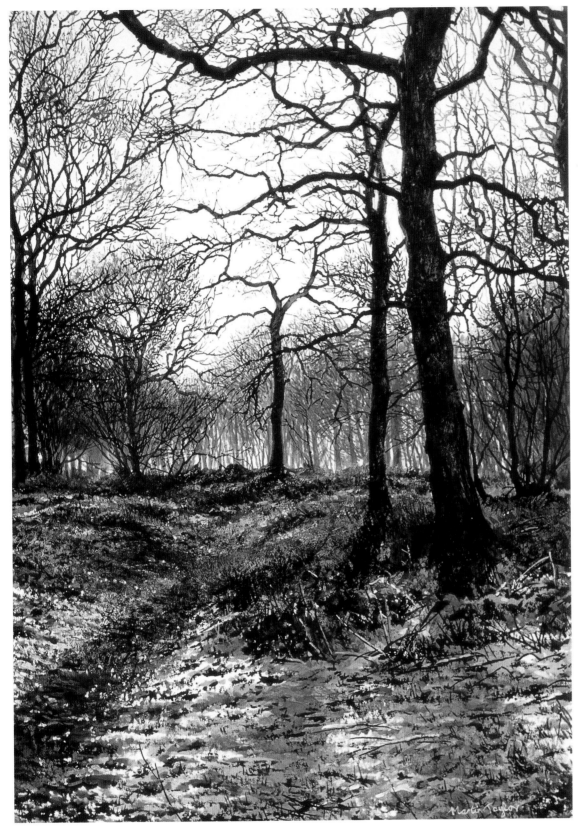

MARTIN TAYLOR

Snow lights

3 parts ultramarine blue +
1 part cerulean blue +
1 dot Naples yellow +
1 dot magenta

Snow darks

1 part ultramarine blue +
1 dot Indian yellow

Ground yellow

1 part burnt sienna +
1 part Indian yellow +
1 part Naples yellow

Ground red-orange

1 part Indian yellow +
1 part crimson

Ground green

1 part Naples yellow +
1 dot ultramarine blue

Ground darks

2 parts crimson +
2 parts ultramarine blue +
1 part sap green

Leaf light yellow

1 part lemon yellow +
1 part Naples yellow

Leaf dark yellow

1 part burnt sienna +
1 part Indian yellow +
1 part Naples yellow

Leaf orange

1 part Indian yellow +
1 part crimson

Tree trunks

1 part burnt sienna +
1 dot ultramarine blue +
1 dot crimson

Water purple

2 parts ultramarine blue +
1 part magenta +
1 part cerulean blue +
1 dot Naples yellow

Water brown

1 part burnt umber +
1 dot Payne's gray

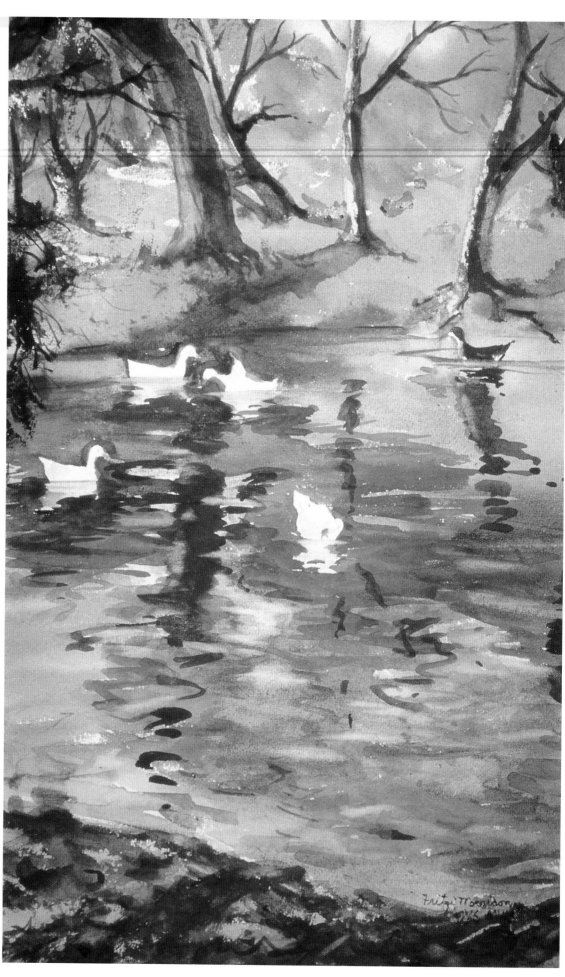

FRITZI MORRISON

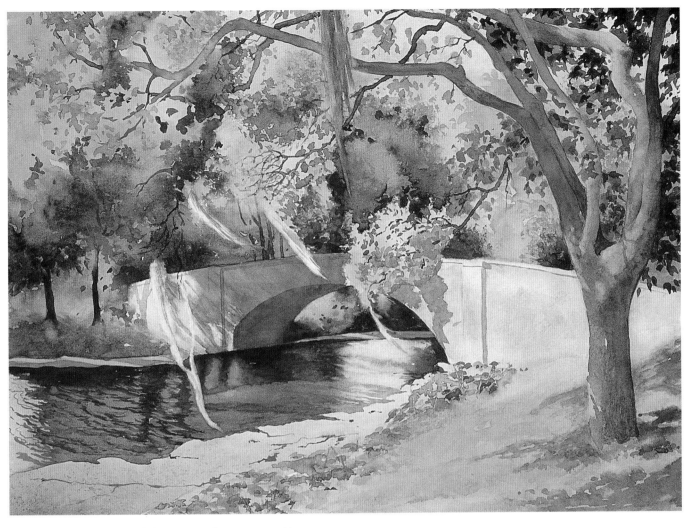

BARBARA FUDURICH *(See template on page 96.)*

Bridge detail

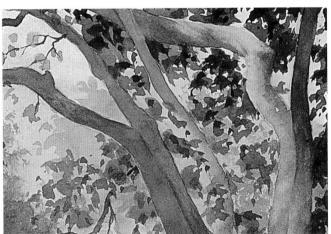

Tree detail

Bridge shadows

1 part Naples yellow +
1 part blue-violet +
1 dot magenta

Foreground

1 part Indian yellow +
1 part burnt sienna

Foliage lights

1 part lemon yellow +
1 dot crimson +
1 dot burnt sienna

Foliage midtones

1 part sap green +
1 dot ultramarine blue +
1 dot crimson

Foliage darks

1 part ultramarine blue +
1 part crimson +
1 part sap green

Tree trunks

1 part burnt umber +
1 dot ultramarine blue

Lighthouse shadows

3 parts ultramarine blue +
2 parts burnt umber

*Lighthouse
midtones*

2 parts ultramarine blue +
1 part burnt sienna

Lighthouse lights

2 parts ultramarine blue +
1 part burnt sienna +
more water

Rooftop

1 part crimson +
1 part burnt sienna +
1 dot ultramarine blue

Tree brown-green

1 part crimson +
1 part sap green

Tree green

3 parts crimson +
2 parts sap green

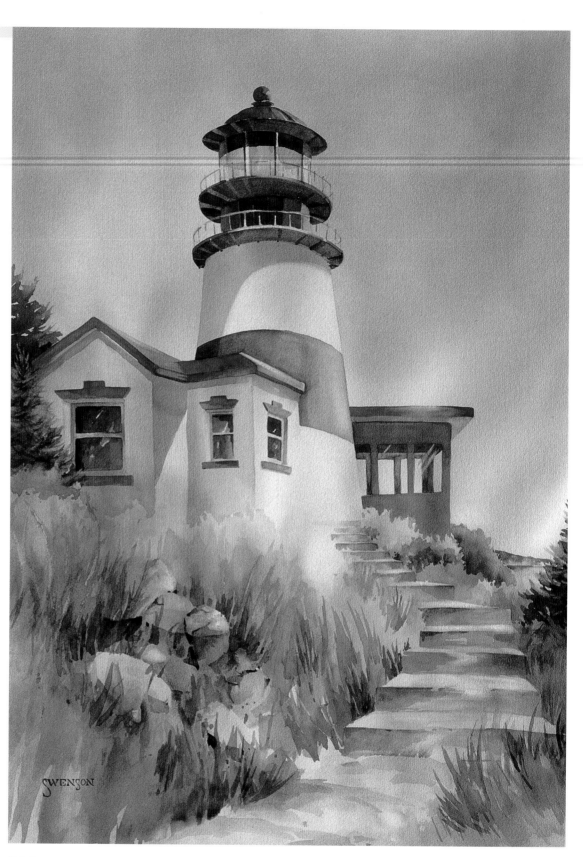

BRENDA SWENSON *(See template on page 97.)*

Foliage

1 part crimson +
1 part sap green

Reed lights

2 parts burnt sienna +
2 parts Naples yellow +
1 dot ultramarine blue

Reed midtones

1 part Indian yellow +
2 dots crimson

Brown building

1 part burnt sienna +
1 dot ultramarine blue +
1 dot crimson

Step lights

1 part Naples yellow +
1 dot blue-violet +
1 dot magenta

Step midtones

1 part burnt sienna +
1 part ultramarine blue

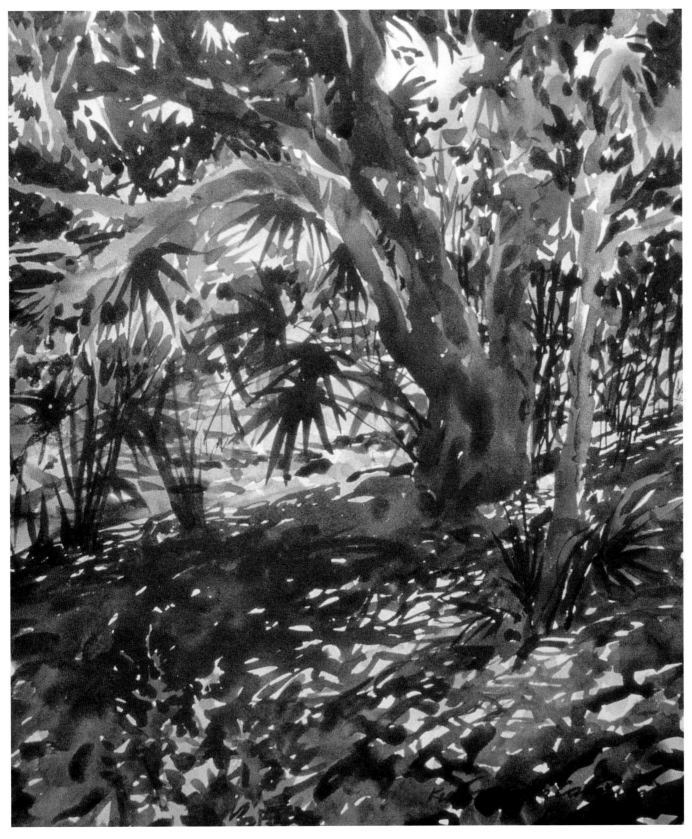

BRYN CRAIG

Leaf bright green

1 part Hooker's green +
1 dot cerulean blue

Leaf yellow

1 part lemon yellow +
1 dot crimson +
1 dot burnt sienna

Leaf blue-green

1 part cerulean blue +
1 dot burnt umber +
1 dot Payne's gray

Leaf shadow blue

2 parts ultramarine blue +
1 dot Hooker's green

Leaf shadow darks

1 part Hooker's green +
1 part crimson +
1 part ultramarine blue

Tree trunk shadows

1 part burnt sienna +
1 part crimson +
1 part cerulean blue +
1 part ultramarine blue

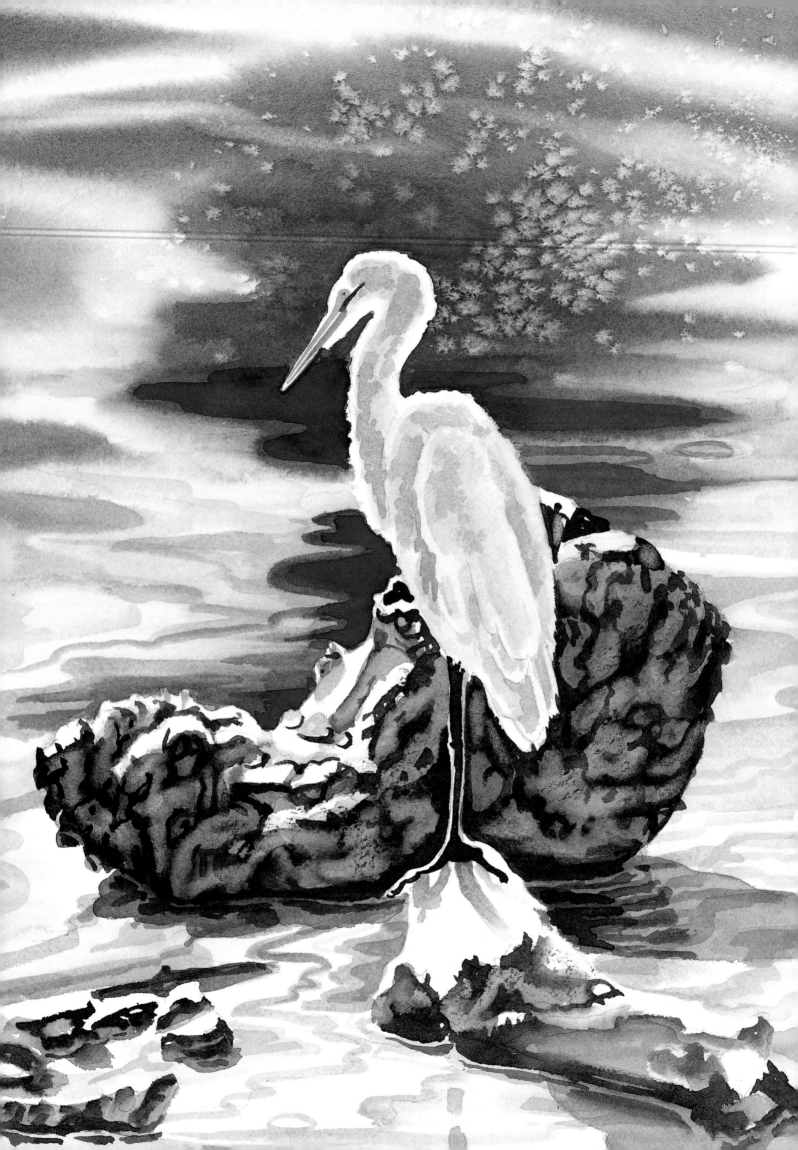

CHAPTER 2

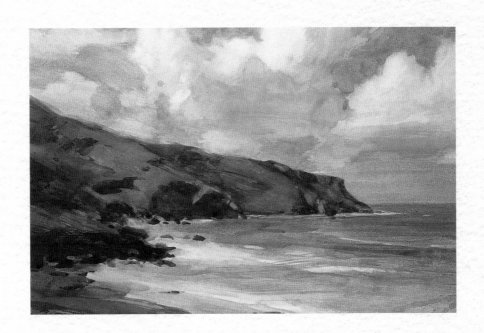

Seascapes

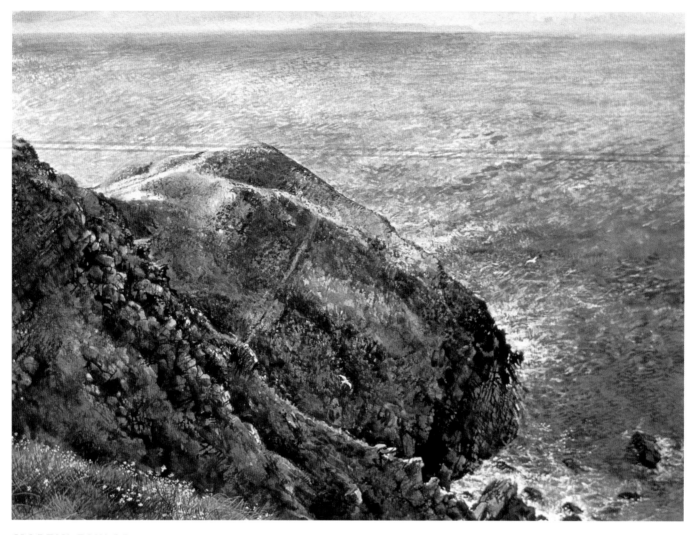

MARTIN TAYLOR

Rock and foliage detail

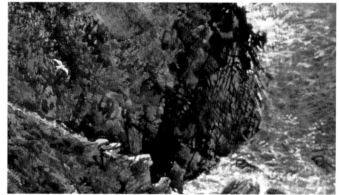

Crashing wave detail

Water

1 part ultramarine blue +
1 dot magenta +
1 dot burnt umber

Reflections in water

1 part burnt umber +
1 part burnt sienna +
1 part ultramarine blue

Grass

1 part crimson +
1 part sap green

Rock lights

1 part burnt umber +
1 dot Naples yellow

Rock darks

1 part crimson +
1 part magenta +
1 part sap green +
1 dot ultramarine blue

Rock shadows

1 part ultramarine blue +
1 part crimson +
1 part burnt umber +
1 dot blue-violet

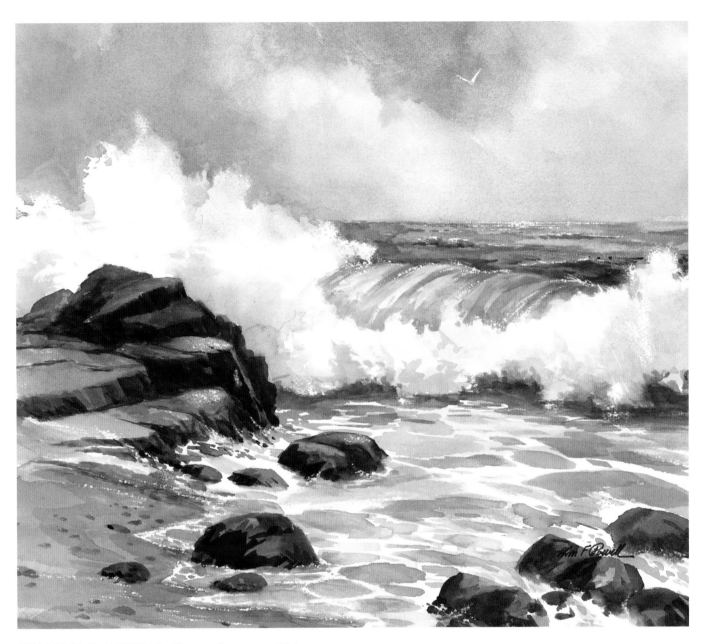

WILLIAM F. POWELL *(See template on page 98.)*

Water lights

1 part ultramarine blue +
1 dot crimson +
1 dot cerulean blue

Water darks

1 part cerulean blue +
1 part lemon yellow +
1 dot magenta

Water shadows

1 part cerulean blue +
1 dot magenta +
1 dot lemon yellow +
1 dot crimson

Water green

1 part lemon yellow +
1 dot ultramarine blue

Water yellow

2 parts lemon yellow +
1 dot ultramarine blue

Sand

1 part burnt umber +
1 dot Naples yellow

Rock lights

1 part burnt sienna +
1 part burnt umber +
1 dot ultramarine blue

Rock midtones

1 part ultramarine blue +
1 part burnt umber +
1 dot burnt sienna

Rock shadows

1 part burnt umber +
1 part ultramarine blue +
1 part sap green

Sky purple

1 part ultramarine blue +
1 dot magenta +
1 dot burnt umber

Sky blue

1 part cerulean blue +
1 dot ultramarine blue

Clouds

1 part cerulean blue +
1 part Naples yellow

Sky

1 part cerulean blue +
1 part ultramarine blue

Water purple

1 part cerulean blue +
1 dot burnt umber +
1 dot blue-violet

Water darks

1 part ultramarine blue +
1 dot burnt sienna +
1 dot cerulean blue

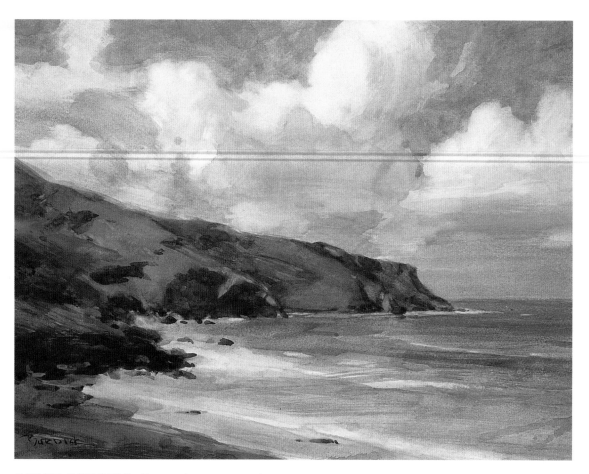

SCOTT BURDICK *(See template on page 99.)*

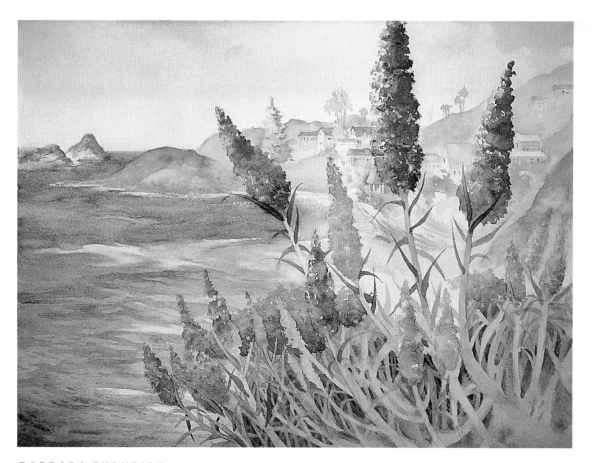

BARBARA FUDURICH *(See template on page 100.)*

Flower purple

1 part blue-violet +
1 part cerulean blue +
1 dot burnt umber

Flower pink

1 part magenta +
2 dots cerulean blue +
1 dot burnt umber

Flower stems

1 part crimson +
1 part ultramarine blue +
1 part sap green +
1 dot burnt umber

Wave midtones

1 part cerulean blue +
1 dot ultramarine blue

Wave darks

2 parts ultramarine blue +
1 part cerulean blue +
1 dot crimson +
1 dot burnt umber

Sky

2 parts ultramarine blue
+ 1 part burnt sienna

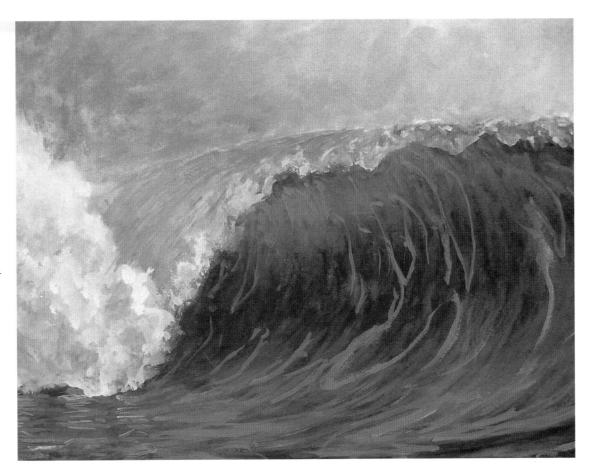

STEPHANIE GOLDMAN *(See template on page 101.)*

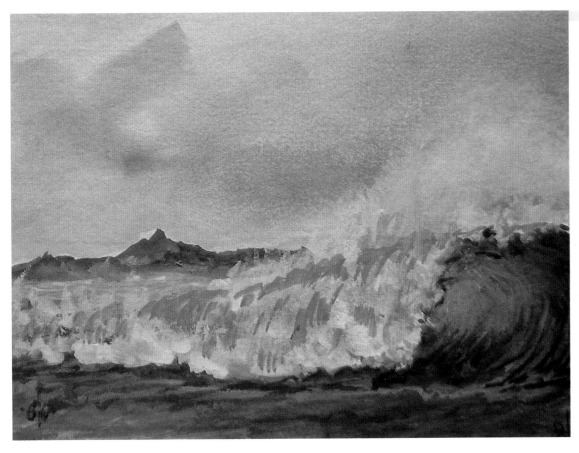

Wave lights

Cerulean blue

Water accents

1 part cerulean blue +
1 dot blue-violet +
1 dot ultramarine blue

Wave darks

1 part blue-violet +
1 part Hooker's green

STEPHANIE GOLDMAN

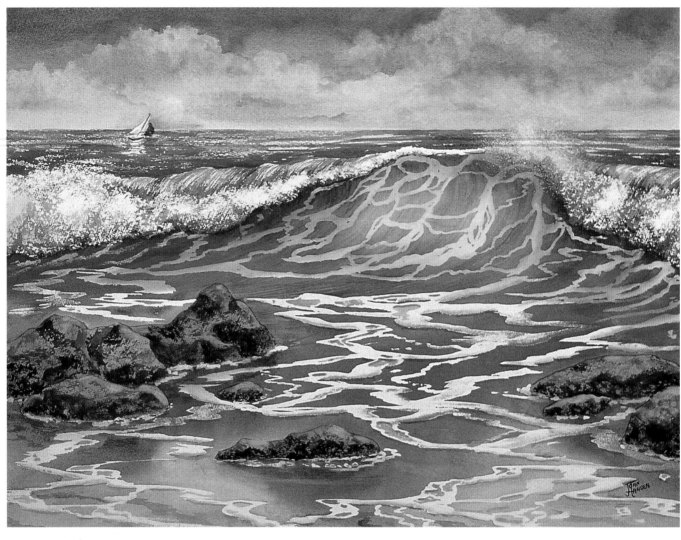

JOAN HANSEN

Wave detail

Shore detail

Rock midtones

1 part Indian yellow +
1 dot burnt umber

Rock shadows

1 part Indian yellow +
2 dots blue-violet +
1 dot burnt sienna

Water yellow

2 parts lemon yellow +
1 dot ultramarine blue

Water green

1 part Hooker's green +
1 dot ultramarine blue

Water purple

2 parts blue-violet +
2 parts ultramarine blue +
1 part burnt umber

Water shadows

1 part ultramarine blue +
1 dot crimson +
1 dot burnt umber

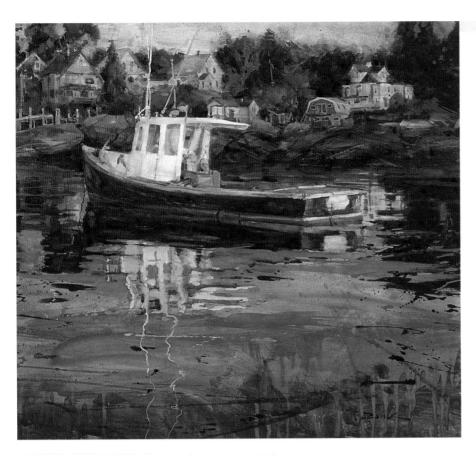

Buildings

1 part burnt sienna +
1 part ultramarine blue

Rooftops

1 part blue-violet +
1 part burnt umber

Shore

1 part burnt sienna +
1 dot ultramarine blue +
1 dot crimson

Water

1 part ultramarine blue +
1 part cerulean blue +
1 dot burnt umber +
1 dot blue-violet

Boat trim

1 part crimson +
1 dot burnt umber

Trees

1 part Hooker's green +
1 part crimson +
1 dot Naples yellow

SCOTT BURDICK *(See template on page 102.)*

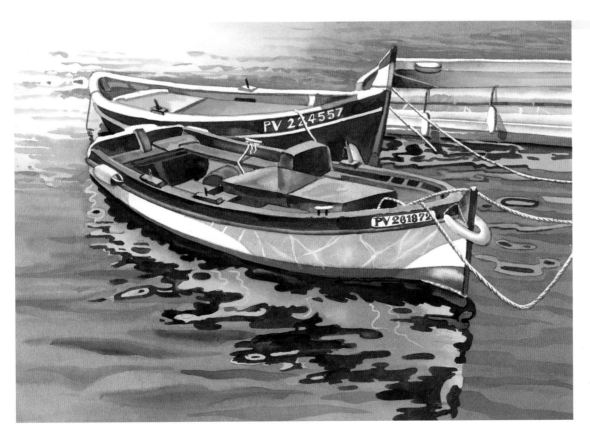

Water lights

Cerulean blue

Water midtones

1 part cerulean blue +
1 dot ultramarine blue

Reflection shadows

2 parts ultramarine blue +
1 part blue-violet +
1 part burnt umber

GERI MEDWAY *(See template on page 103.)*

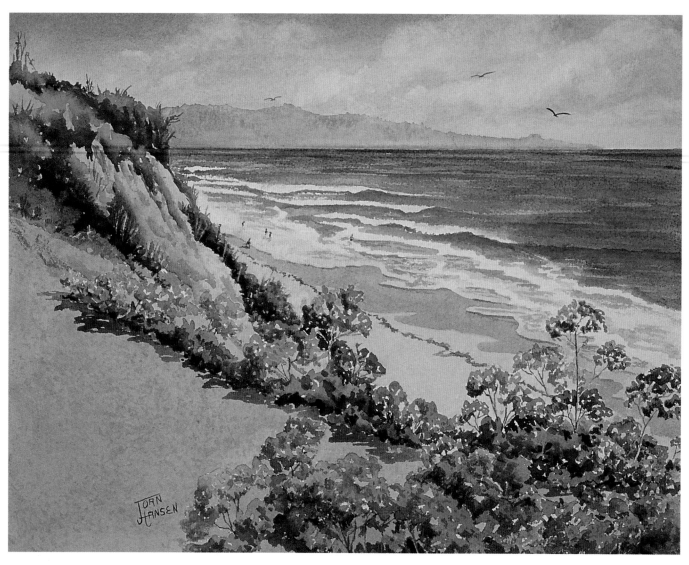

JOAN HANSEN

Flowers

2 parts blue-violet +
2 parts ultramarine blue +
1 part burnt umber

Foliage

1 part sap green +
2 dots crimson +
1 dot Naples yellow

Sand

1 part burnt umber +
1 dot burnt sienna

Flower darks

1 part blue-violet +
1 dot burnt umber +
1 dot Indian yellow

Foliage darks

1 part sap green +
2 dots ultramarine blue +
2 dots crimson

Sand shadows

2 parts burnt umber +
1 part ultramarine blue +
1 dot burnt sienna

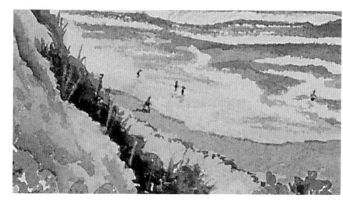

Shore detail

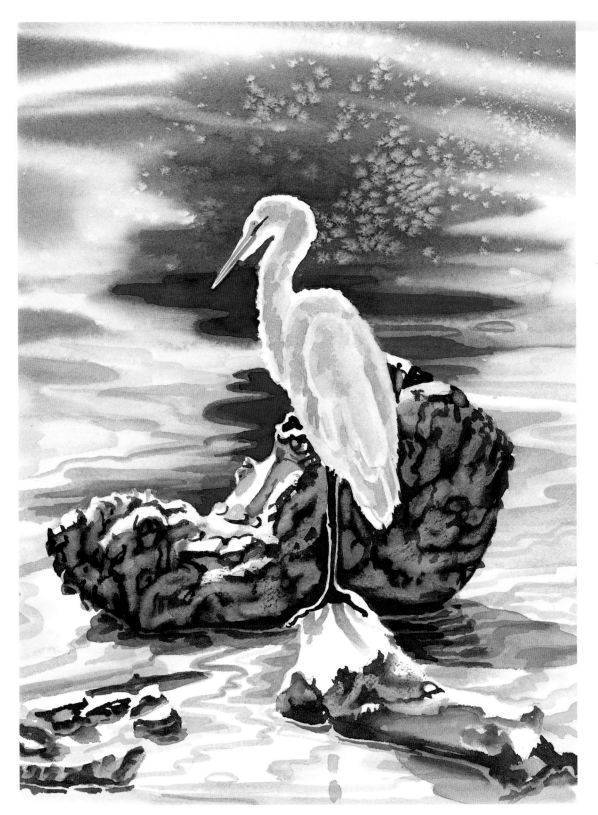

Water lights

1 part cerulean blue +
1 part lemon yellow

Water darks

1 part ultramarine blue +
1 dot burnt sienna

Rock reflections

1 part magenta +
1 part ultramarine blue

Rock lights

1 part burnt umber +
1 dot Payne's gray

Rock midtones

1 part burnt sienna +
1 dot burnt umber

Rock darks

1 part burnt umber +
1 part Payne's gray

GERI MEDWAY *(See template on page 104.)*

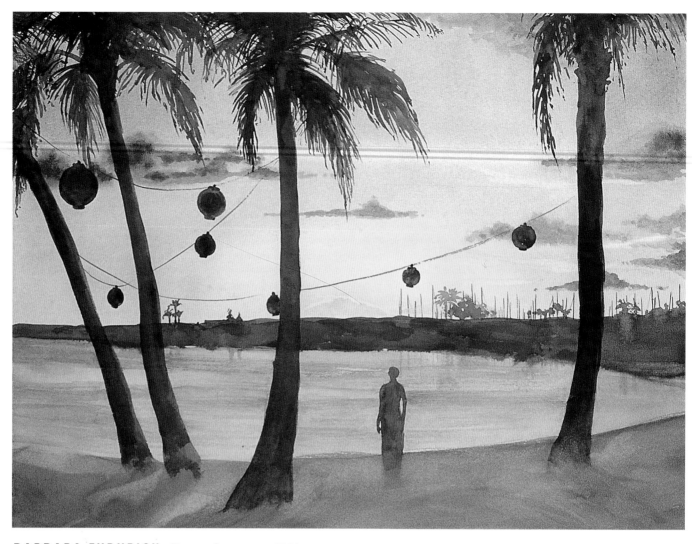

BARBARA FUDURICH *(See template on page 105.)*

Sky and tree detail

Silhouette detail

Trees

1 part Payne's gray +
1 dot blue-violet +
1 dot crimson

Sky purple

1 part ultramarine blue +
2 dots crimson

Sunset yellow

1 part lemon yellow +
1 dot Indian yellow +
1 dot burnt sienna

*Water
reflection orange*

1 part burnt sienna +
1 part Indian yellow +
1 part burnt umber

Shore shadows

1 part burnt umber +
1 part blue-violet +
1 dot burnt sienna +
1 dot crimson

Shore midtones

1 part burnt umber +
1 part blue-violet +
1 dot burnt sienna +
1 dot crimson +
more water

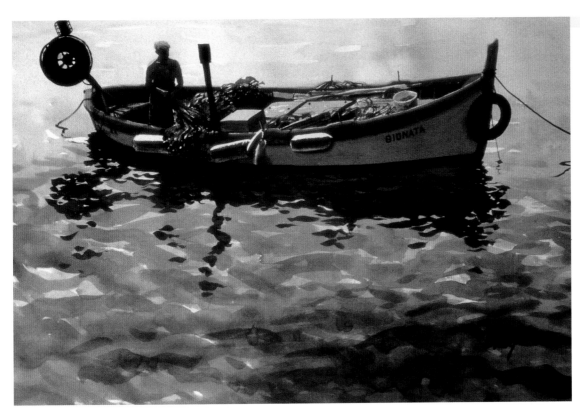

BRYN CRAIG *(See template on page 106.)*

Water blue

1 part cerulean blue +
1 dot Payne's gray

Water green

1 part sap green +
1 part ultramarine blue +
1 dot Payne's gray

Water shadows

2 parts crimson +
1 part sap green +
1 part ultramarine blue

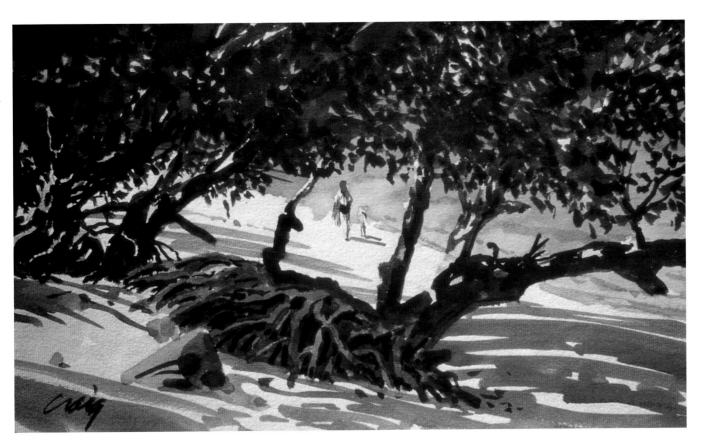

BRYN CRAIG *(See template on page 106.)*

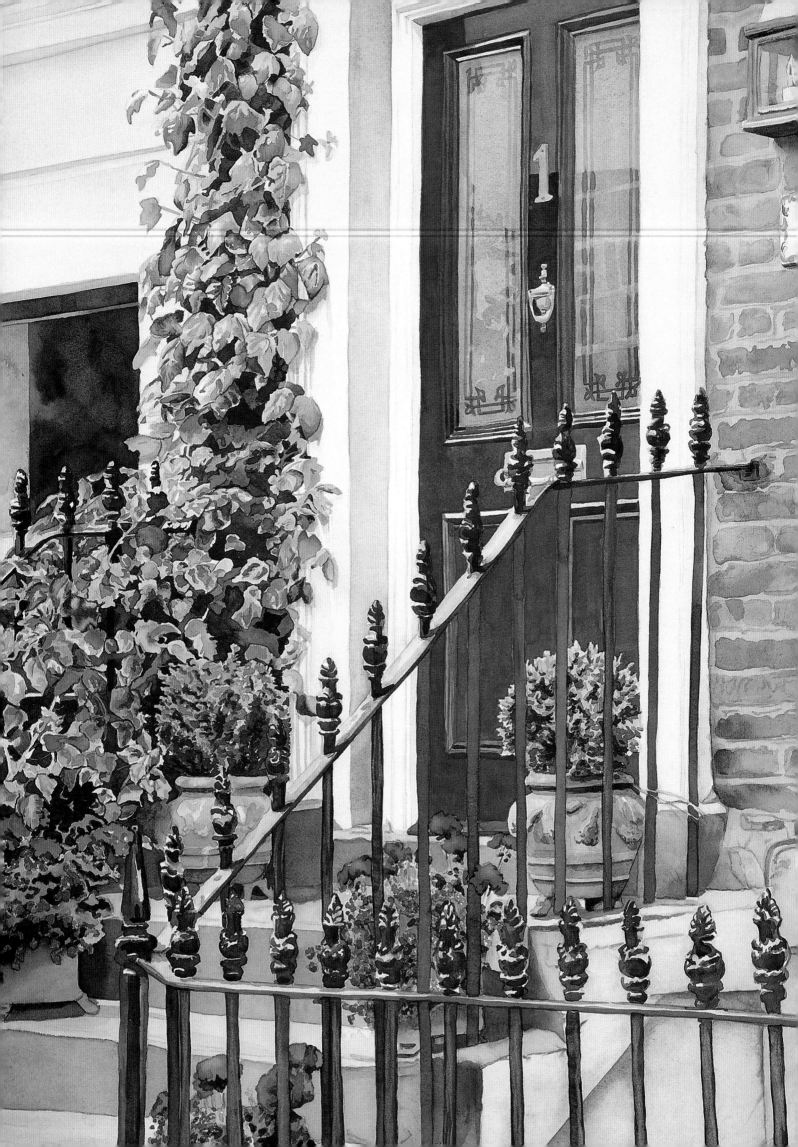

CHAPTER 3

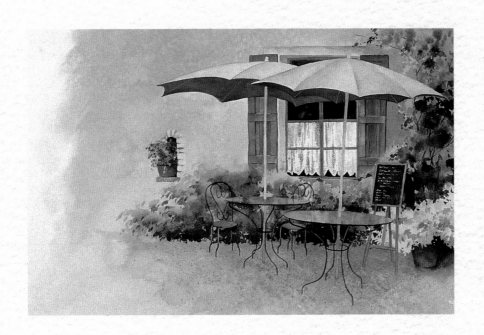

Scenes

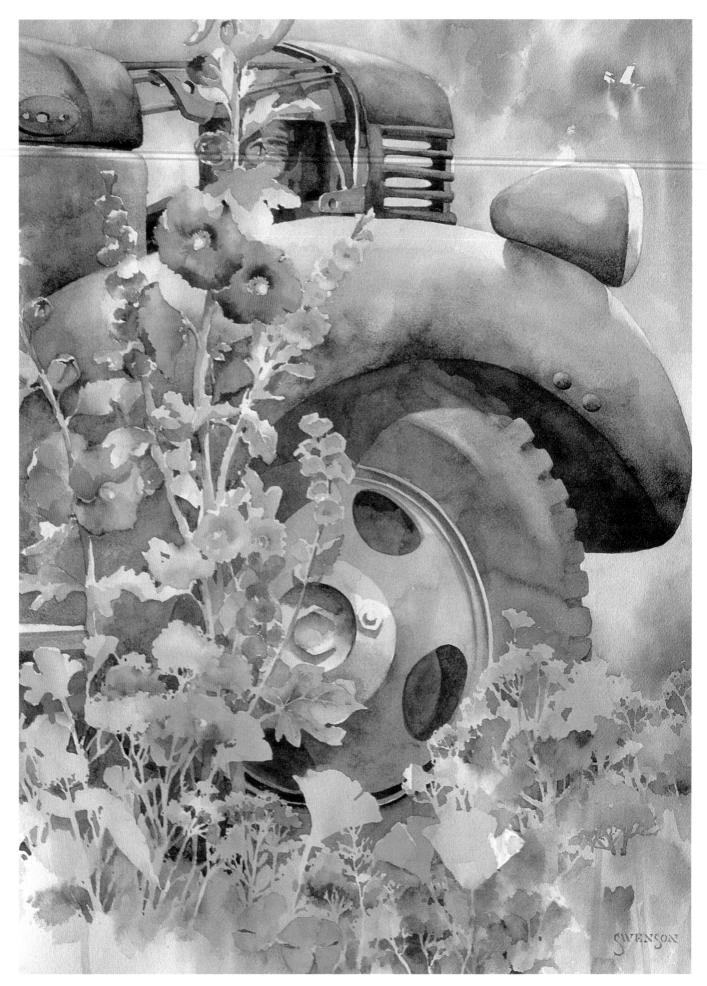

BRENDA SWENSON

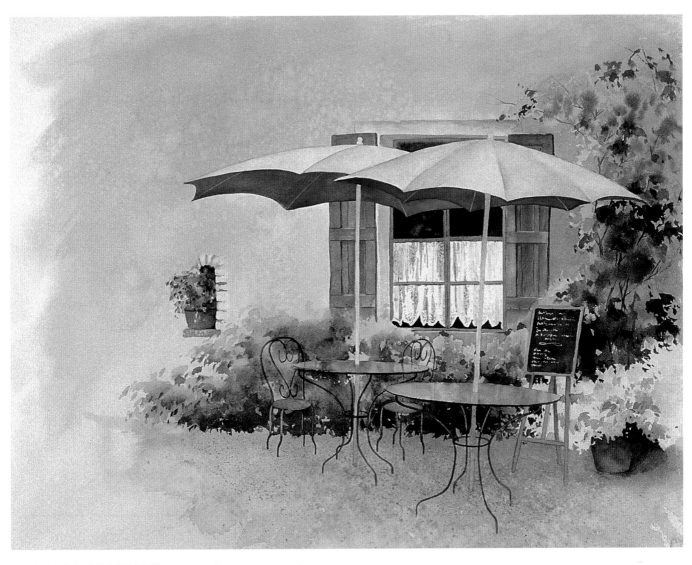

BARBARA FUDURICH *(See template on page 107.)*

Umbrella darks

1 part ultramarine blue +
1 dot Naples yellow

Wall

1 part burnt sienna +
1 part burnt umber +
1 part Naples yellow

Foliage lights

1 part lemon yellow +
1 dot burnt umber

Foliage midtones

1¼ parts crimson +
1 part sap green +
1 part ultramarine blue +
1 dot lemon yellow

Foliage darks

2 parts ultramarine blue +
2 parts sap green +
1 part burnt umber

Window frame

1 part burnt sienna +
1 dot Indian yellow +
1 dot crimson

Flower pots

1 part crimson +
1 dot burnt umber +
1 dot burnt sienna

Window shutters

1 part ultramarine blue +
1 dot crimson

Window darks

2 parts crimson +
1 part Payne's gray

Chalkboard

1 part burnt umber +
1 part blue-violet +
1 dot burnt sienna +
1 dot crimson

Ground

1 part Payne's gray +
1 part crimson +
1 part blue-violet +
1 part Naples yellow

Chair seat

1 part cerulean blue +
1 dot sap green +
1 dot Payne's gray

Door lights

1 part ultramarine blue +
1 part cerulean blue

Door midtones

2 parts ultramarine blue +
1 part cerulean blue +
1 dot Payne's gray

Railing darks

1 part ultramarine blue +
1 part Payne's gray

Leaf lights

1 part lemon yellow +
1 dot burnt umber

Leaf midtones

1½ parts sap green +
1 part ultramarine blue

Leaf darks

1 part blue-violet +
1 part cerulean blue +
1 part ultramarine blue +
1 dot sap green

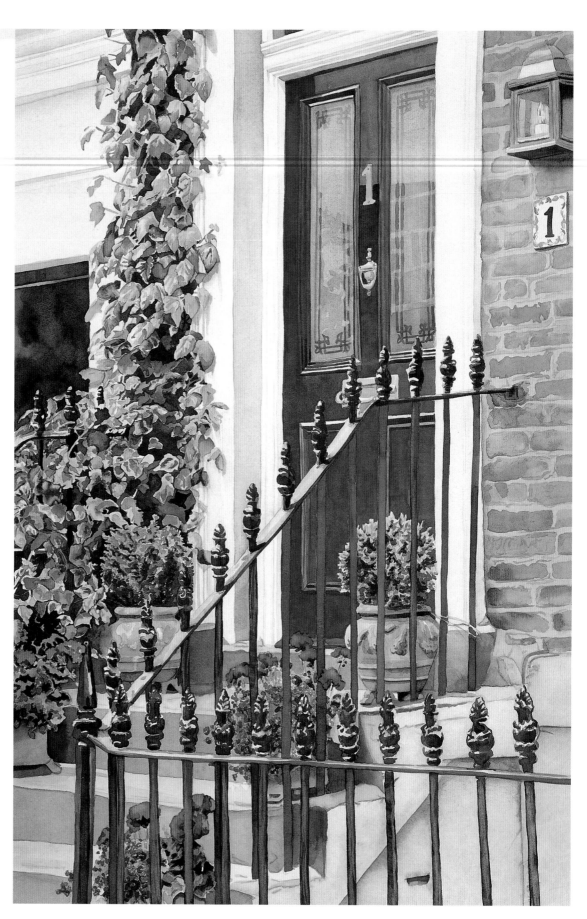

MARY KAY WILSON *(See template on page 108.)*

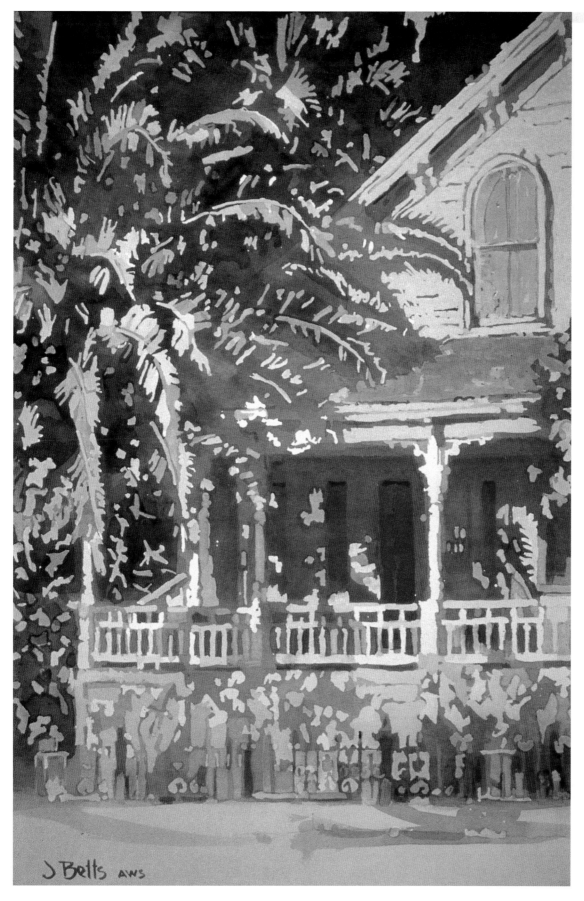

J Betts aws

JUDI BETTS

Blue leaves

1 part cerulean blue +
1 part ultramarine blue +
1 part crimson

Green leaves

1 part lemon yellow +
1 part crimson +
1 part sap green

Lavender leaves

1 part magenta +
1 dot blue-violet

Pink leaves

2 parts crimson +
1 dot magenta

Yellow leaves

2 parts lemon yellow +
1 dot Indian yellow

Orange leaves

1 part Naples yellow +
1 part Indian yellow +
1 dot crimson

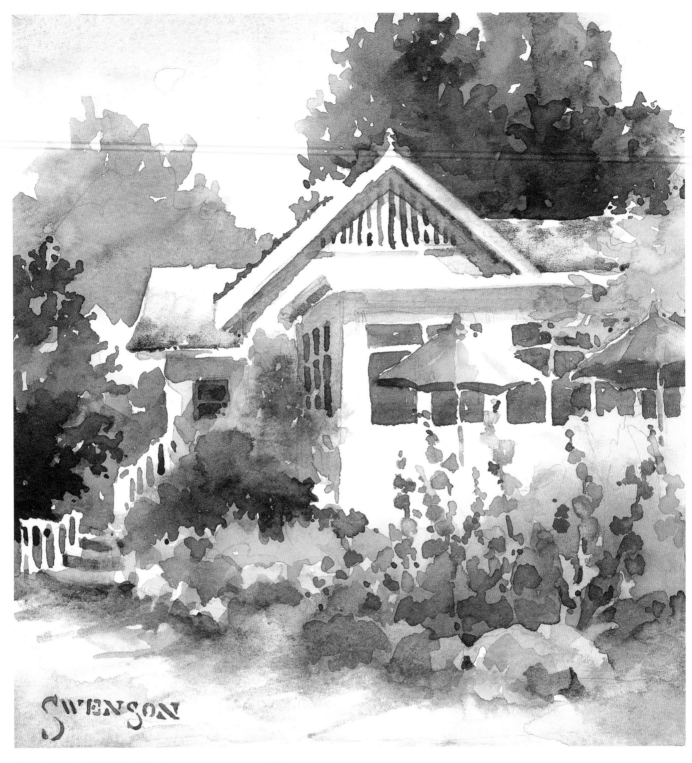

BRENDA SWENSON *(See template on page 109.)*

Tree lights	*Tree midtones*	*Tree darks*	*Tree highlights*	*Building shadows*	*Rooftop shadows*
1 part Naples yellow + 1 dot burnt umber + 1 dot Payne's gray	1 part sap green + 1 part ultramarine blue + 1 dot crimson	1 part crimson + 1 part ultramarine blue + 1 part sap green	1 part Naples yellow + 1 dot ultramarine blue	1 part cerulean blue + 2 dots Payne's gray	1 part Payne's gray + 1 dot ultramarine blue

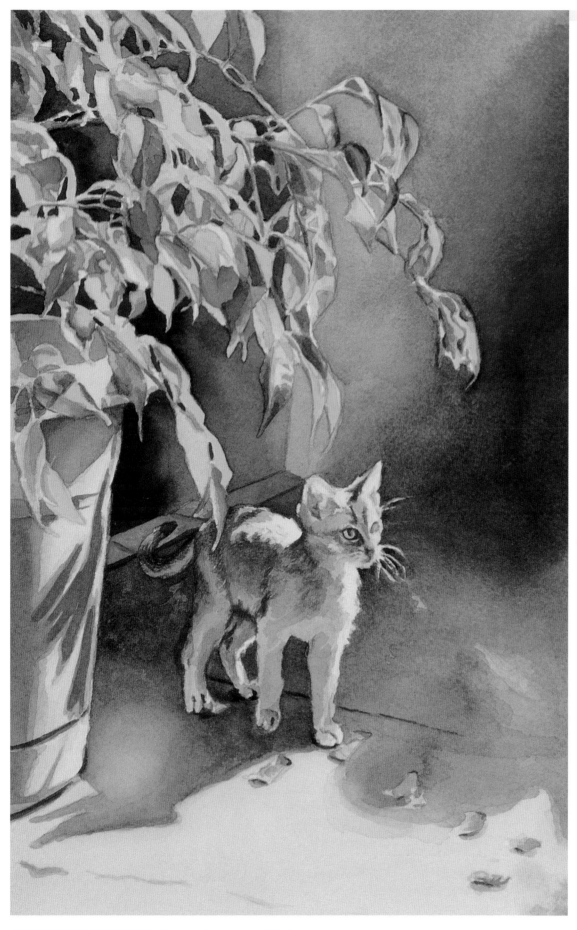

*Foreground
shadow lights*

1 part burnt sienna +
1 part Naples yellow

*Foreground
shadow midtones*

1 part crimson +
1 dot Indian yellow +
1 dot burnt umber

*Foreground
shadow darks*

2 parts Payne's gray +
1 part blue-violet +
1 part burnt sienna

Wall darks

1 part ultramarine blue +
1 part Hooker's green +
1 dot cerulean blue +
1 dot Payne's gray

Wall blue-green

1 part ultramarine blue +
1 part Hooker's green +
1 dot cerulean blue +
1 dot Payne's gray +
more water

Wall blue

2 parts ultramarine blue +
1 part blue-violet +
1 part Naples yellow +
1 dot Payne's gray

MARY KAY WILSON *(See template on page 110.)*

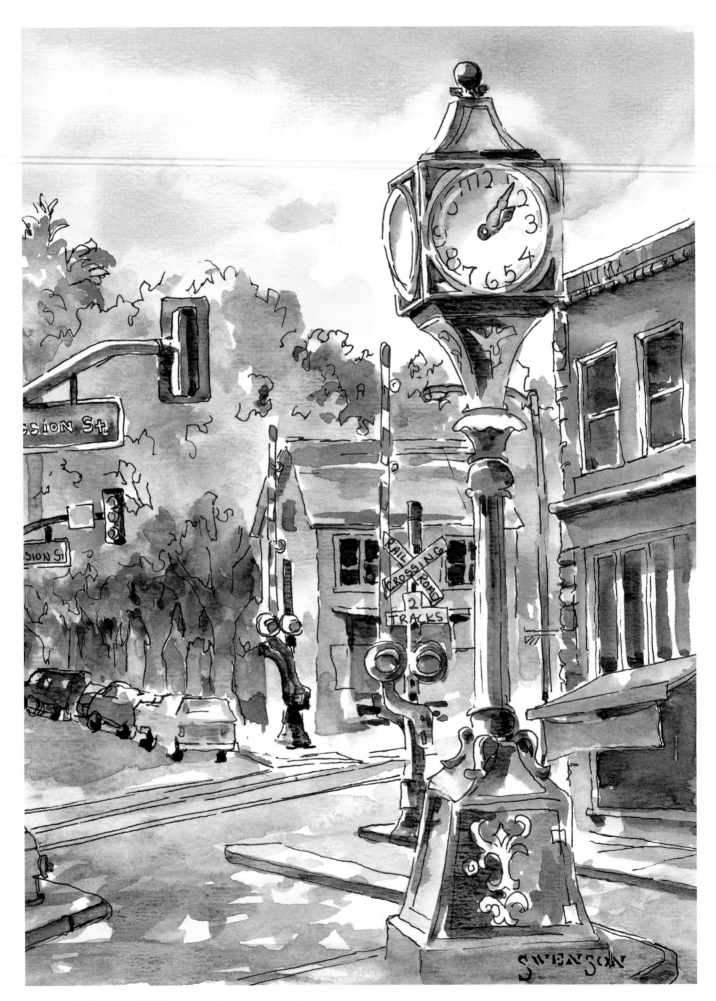

BRENDA SWENSON *(See template on page 111.)*

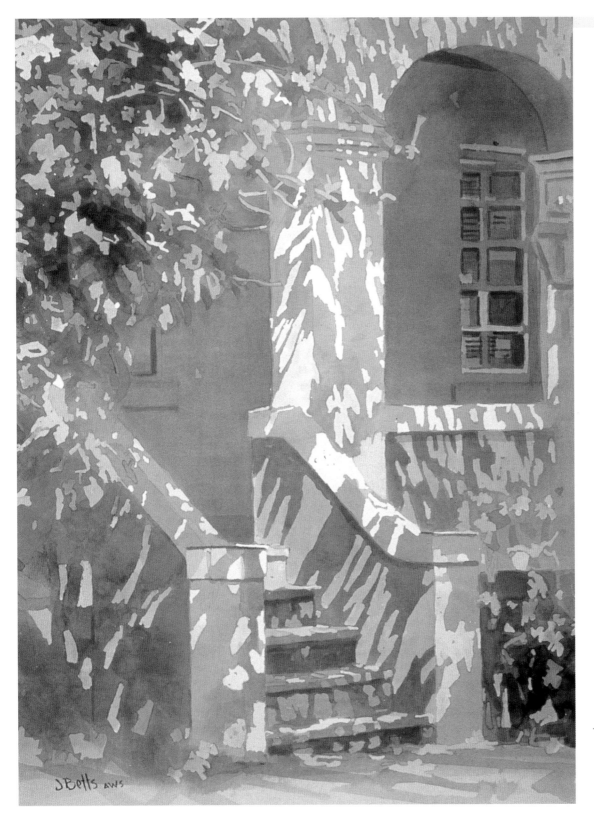

JUDI BETTS *(See template on page 112.)*

Light blue leaves

1 part cerulean blue +
1 part lemon yellow

Dark blue leaves

1 part cerulean blue +
1 part ultramarine blue +
1 part crimson

Lavender leaves

1 part magenta +
1 dot blue-violet

Pink leaves

2 parts crimson +
1 dot magenta

Light yellow leaves

2 parts lemon yellow +
1 dot Indian yellow

Dark yellow leaves

1 part lemon yellow +
1 part Naples yellow

Wall lights

1 part Naples yellow +
1 dot burnt umber +
1 dot Payne's gray

Wall midtones

1 part Naples yellow +
1 dot burnt umber +
1 dot Indian yellow

Wall darks

2 parts Naples yellow +
1 part crimson +
1 dot Payne's gray

Wall shadows

1 part Naples yellow +
1 part crimson +
1 part burnt sienna +
1 dot Payne's gray

Green leaves

1 part lemon yellow +
1 part crimson +
1 part sap green

Orange leaves

1 part Naples yellow +
1 part Indian yellow +
1 dot crimson

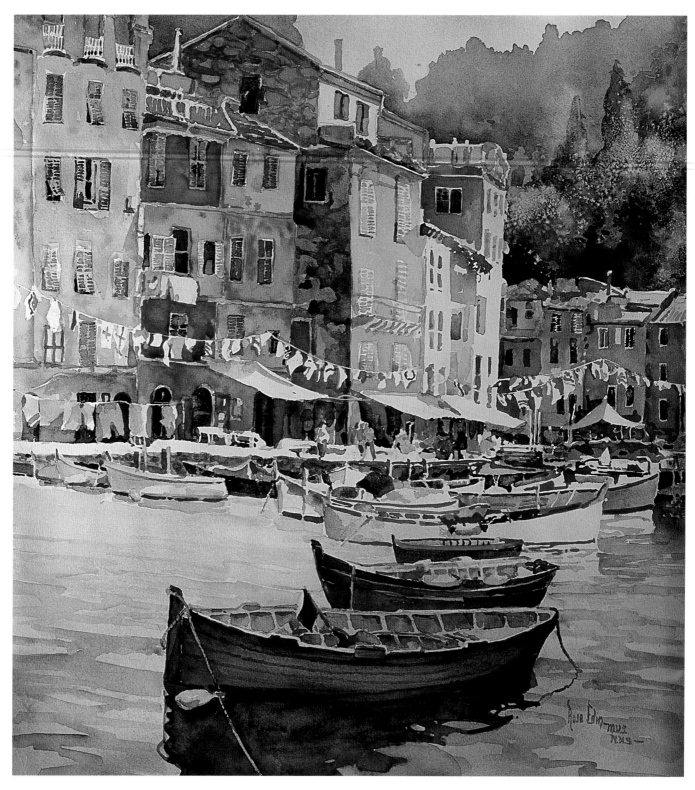

ROSE EDIN *(See template on page 113.)*

Building red

1 part crimson +
1 dot burnt sienna +
1 dot lemon yellow

Building orange

1 part Indian yellow +
1 dot crimson +
1 dot Naples yellow

Building yellow

1 part lemon yellow +
1 dot burnt sienna

Building purple

1 part magenta +
2 dots cerulean blue +
1 dot burnt umber

Building brown

1 part burnt sienna +
1 dot burnt umber +
1 dot crimson

*Building
dark brown*

1 part burnt umber +
1 dot Payne's gray

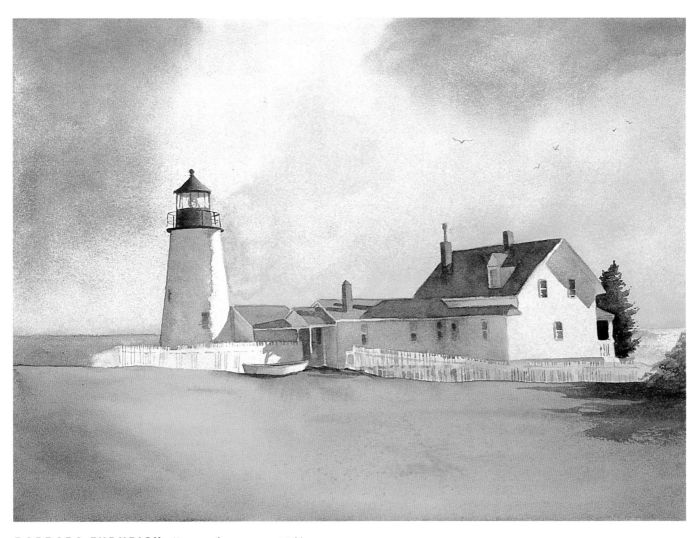

BARBARA FUDURICH *(See template on page 114.)*

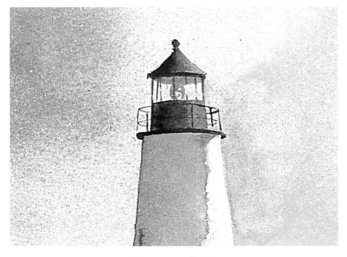

Turret top detail

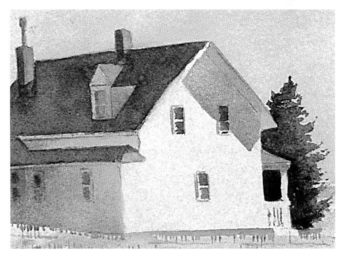

Building detail

Sky	*Turret top midtones*	*Turret top shadows*	*Rooftops*	*Building shadows*	*Chimneys*
2 parts cerulean blue + 1 part ultramarine blue + 1 dot lemon yellow	2 parts Hooker's green + 1 part crimson	1 part ultramarine blue + 1 part Payne's gray	1 part Payne's gray + 1 part burnt umber	1 part Naples yellow + 1 dot ultramarine blue + 1 dot cerulean blue	1 part Naples yellow + 1 part crimson

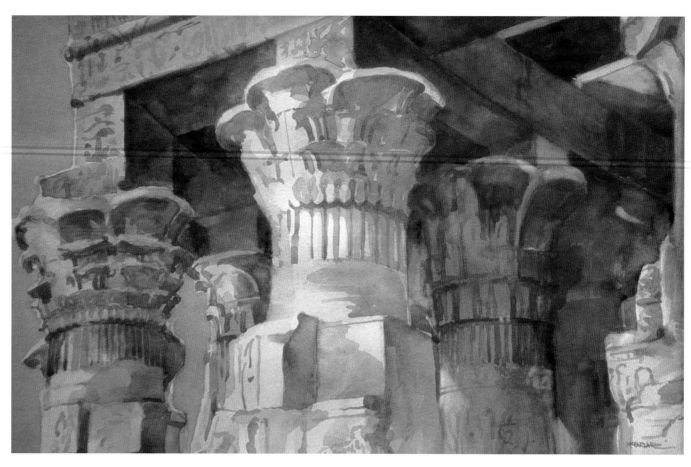

JAMES MCFARLANE *(See template on page 114.)*

Column shadow midtones

1 part burnt sienna +
1 dot magenta +
1 dot Payne's gray

Column shadow lights

1 part burnt sienna +
1 dot magenta +
1 dot Payne's gray +
more water

Column shadow darks

1 part burnt sienna +
1 dot Payne's gray +
1 dot crimson

Column yellow

1 part lemon yellow +
1 dot burnt umber

Column brown

1 part burnt umber +
1 part burnt sienna

Column orange

1 part Indian yellow +
1 dot burnt umber +
1 dot crimson

COLOR MIXES FOR PAGE 53

Wall shadows

1 part burnt sienna +
1 part burnt umber +
1 dot crimson

Wall midtones

1 part burnt sienna +
1 dot burnt umber +
1 dot crimson +
more water

Wall lights

1 part lemon yellow +
1 dot burnt umber

Flower lights

1 part crimson +
1 dot magenta

Flower darks

2 parts crimson +
1 dot Payne's gray

Foreground shadows

1 part blue-violet +
1 part burnt sienna +
1 part Naples yellow

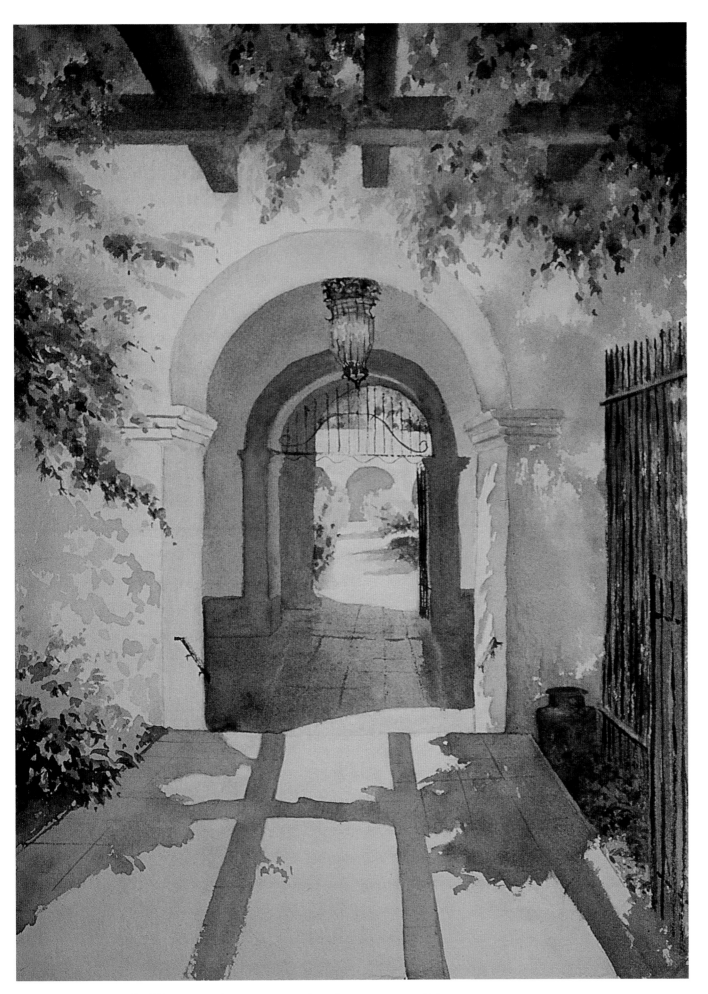

BARBARA FUDURICH *(See template on page 115. See color mixes on page 52.)*

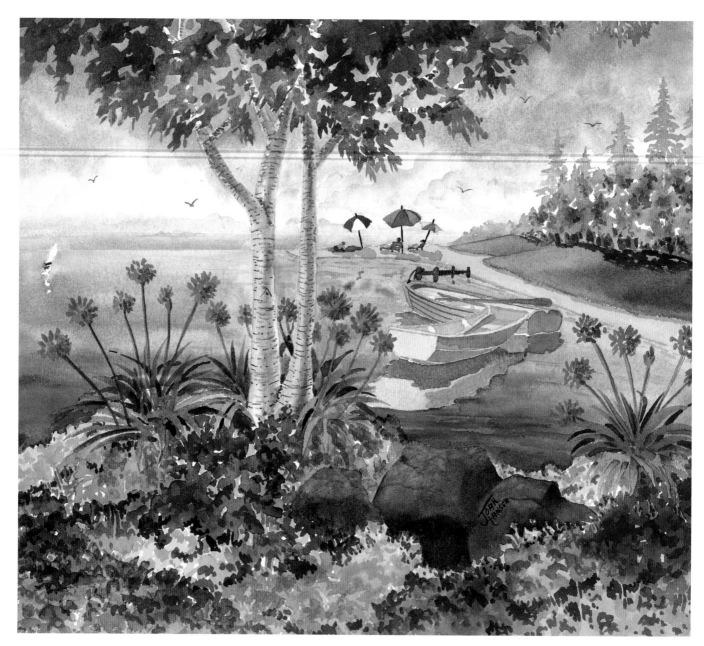

JOAN HANSEN *(See template on page 116.)*

Beach detail

Boat detail

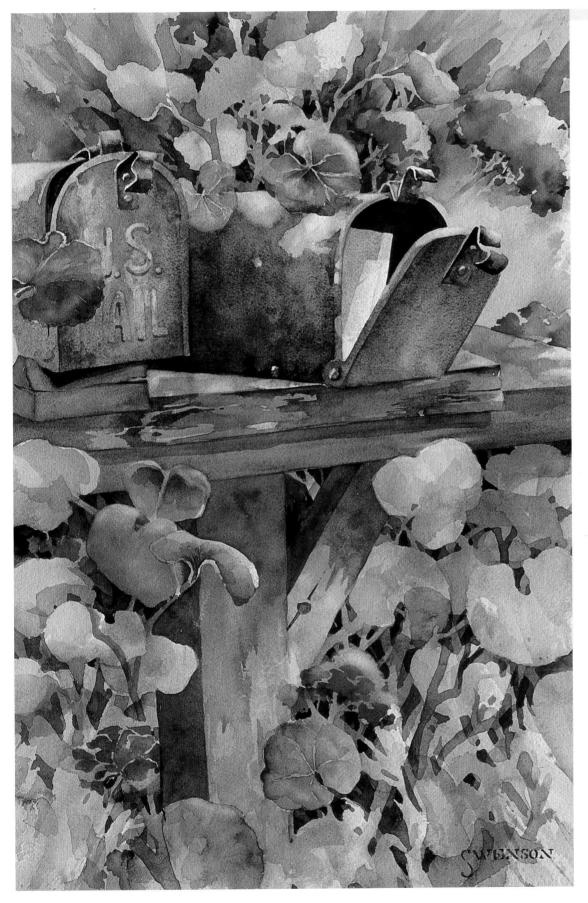

BRENDA SWENSON

Leaf green

1 part sap green +
1 part ultramarine blue +
1 dot crimson +
1 dot lemon yellow

Leaf yellow

2 parts lemon yellow +
1 dot sap green +
1 dot crimson

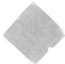

Leaf blue

1 part cerulean blue +
1 dot ultramarine blue

Flower midtones

2 parts lemon yellow +
1 part crimson +

Flower darks

1 part crimson +
1 dot Indian yellow +
1 dot magenta

Flower shadows

2 parts crimson +
1 dot Payne's gray

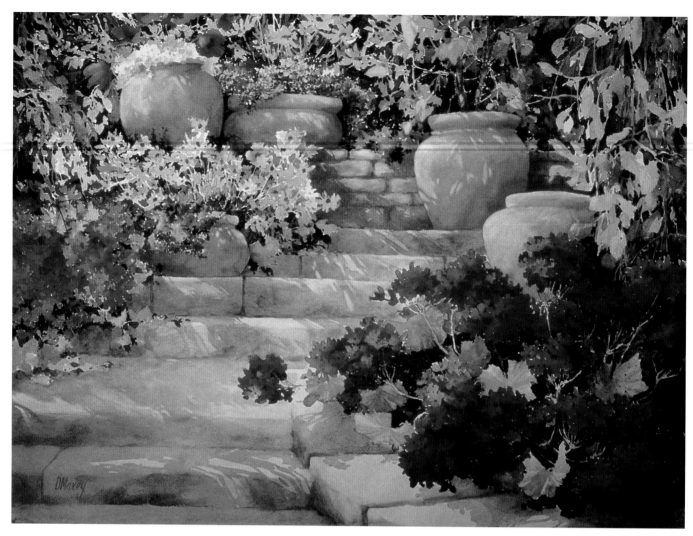

DIANE MAXEY *(See template on page 117.)*

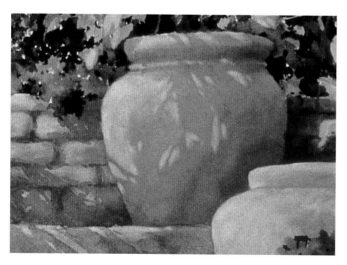

Flower pot detail

Step detail

Flower pot lights

1 part Naples yellow +
1 part burnt sienna +
1 dot burnt umber

Flower pot midtones

1 part burnt sienna +
1 dot burnt umber +
1 dot Naples yellow +
1 dot crimson

Flower pot darks

1 part crimson +
1 part burnt sienna +
2 dots burnt umber

Step lights

1 part ultramarine blue +
1 part cerulean blue

Step midtones

1 part ultramarine blue +
1 dot Payne's gray

Step shadows

2 parts ultramarine blue +
1 part Payne's gray +
1 dot crimson

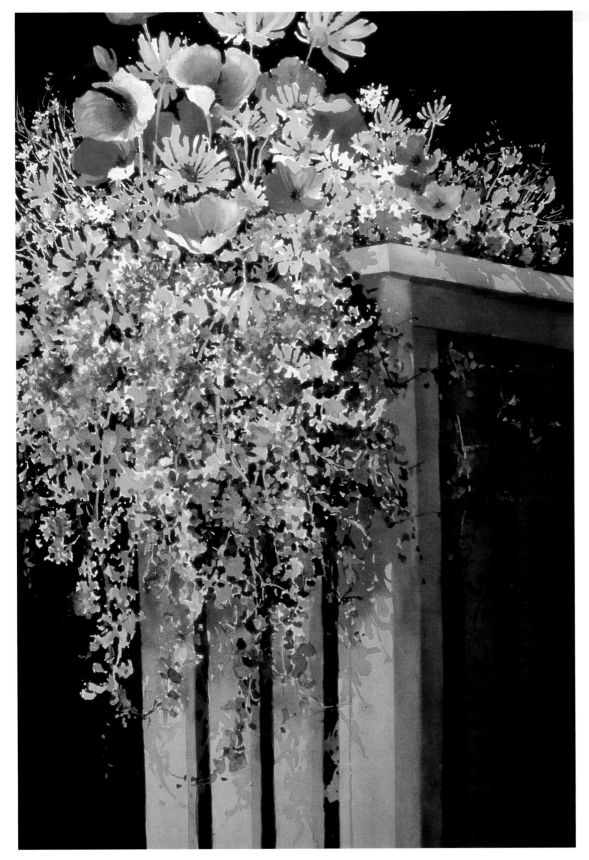

DIANE MAXEY

Planter red

1 part crimson +
1 part Indian yellow

Planter yellow

1 part lemon yellow +
1 part Naples yellow +
1 dot Indian yellow

Planter shadows

1 part crimson +
1 dot Payne's gray +
1 dot burnt umber

Blue flowers

1 part cerulean blue +
1 dot ultramarine blue

Pink flowers

1 part magenta +
1 dot Payne's gray

Purple flowers

Blue-violet

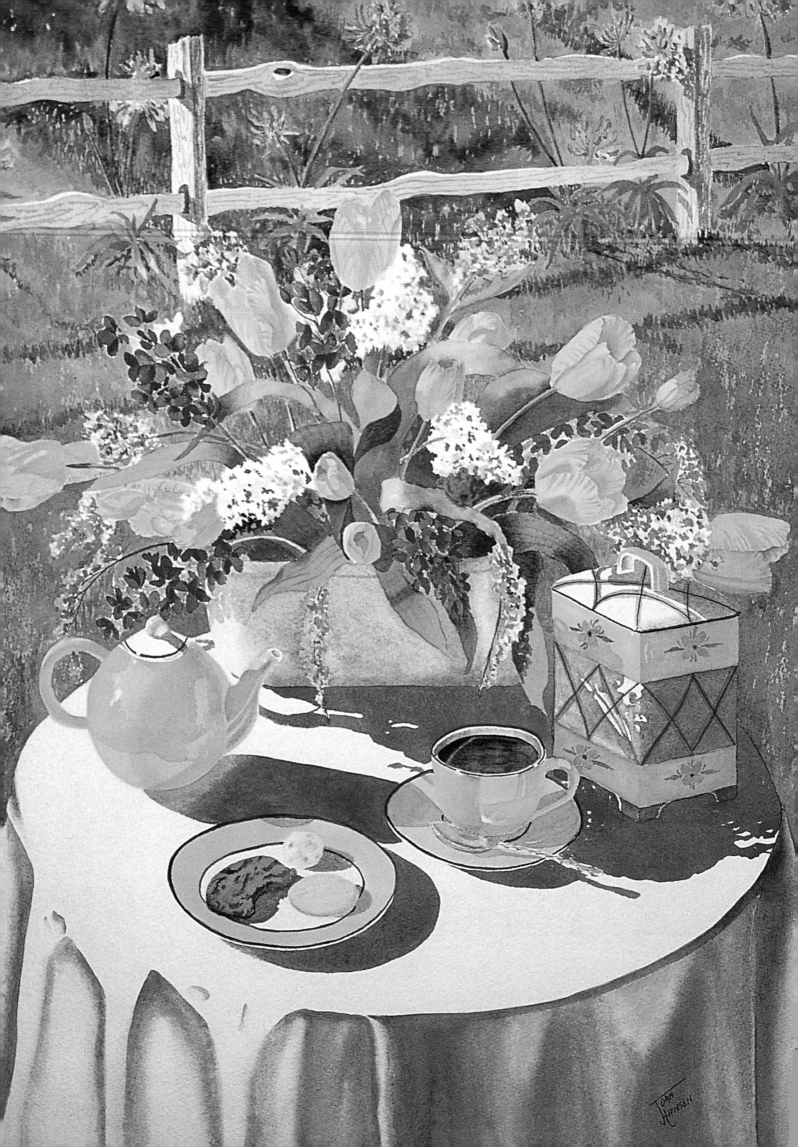

CHAPTER 4

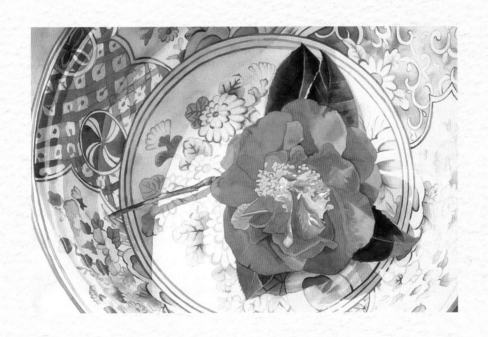

Still Lifes

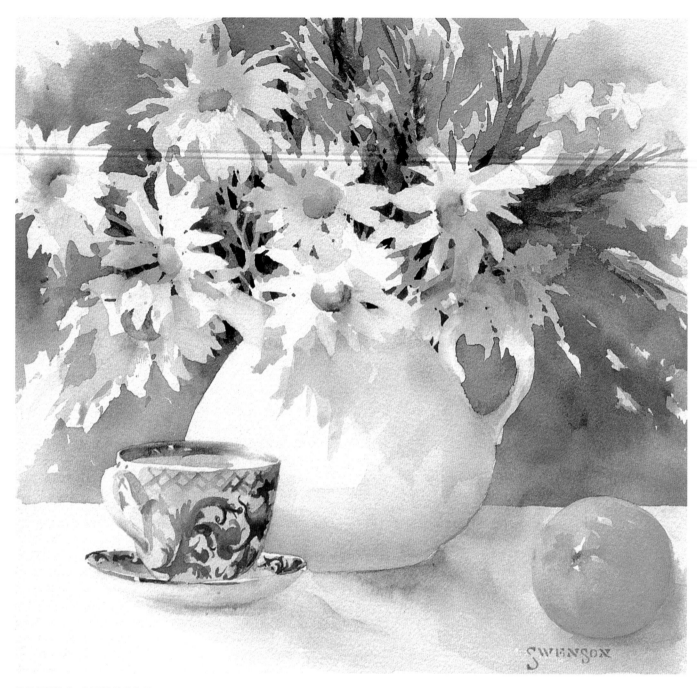

BRENDA SWENSON *(See template on page 118.)*

Teacup design	*Fruit*	*Vase*	*Daisy centers*	*Wall blue*	*Wall blue-gray*
1 part ultramarine blue + 1 part Naples yellow + 1 part Payne's gray	1 part lemon yellow + 1 part Naples yellow + 1 dot crimson	1 part ultramarine blue + 1 part Naples yellow + 1 part burnt umber	1 part burnt sienna + 1 dot Naples yellow + 1 dot crimson	1 part ultramarine blue + 1 dot cerulean blue + 1 dot Payne's gray	1 part Naples yellow + 1 part ultramarine blue

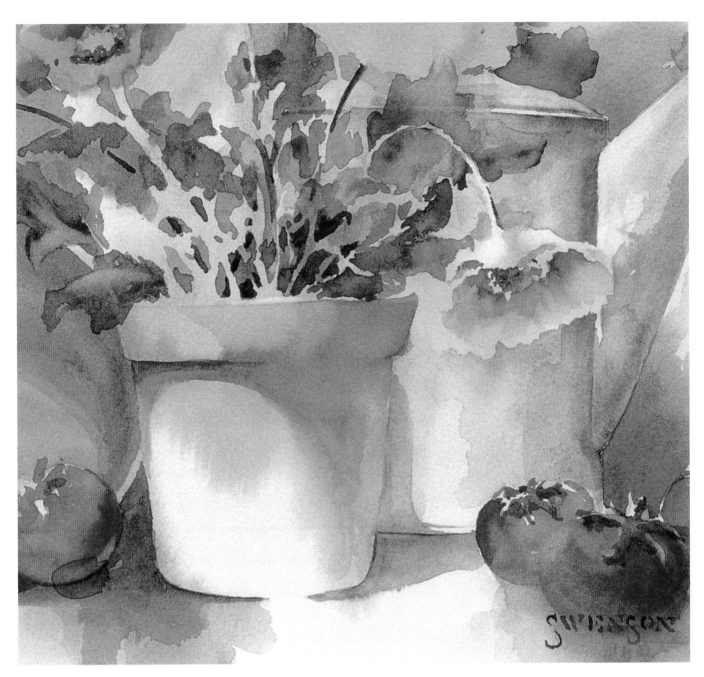

BRENDA SWENSON *(See template on page 119.)*

Flower pot

1 part burnt sienna +
1 dot burnt umber +
1 dot crimson

Leaf brown

2 parts crimson +
1 dot sap green

Leaf green

1¼ parts crimson +
1 part sap green +
1 part ultramarine blue

Flower red

1 part crimson +
1 part burnt sienna

Flower yellow

1 part lemon yellow +
1 dot burnt sienna

Flower purple

1 part ultramarine blue +
1 part crimson +
1 part magenta

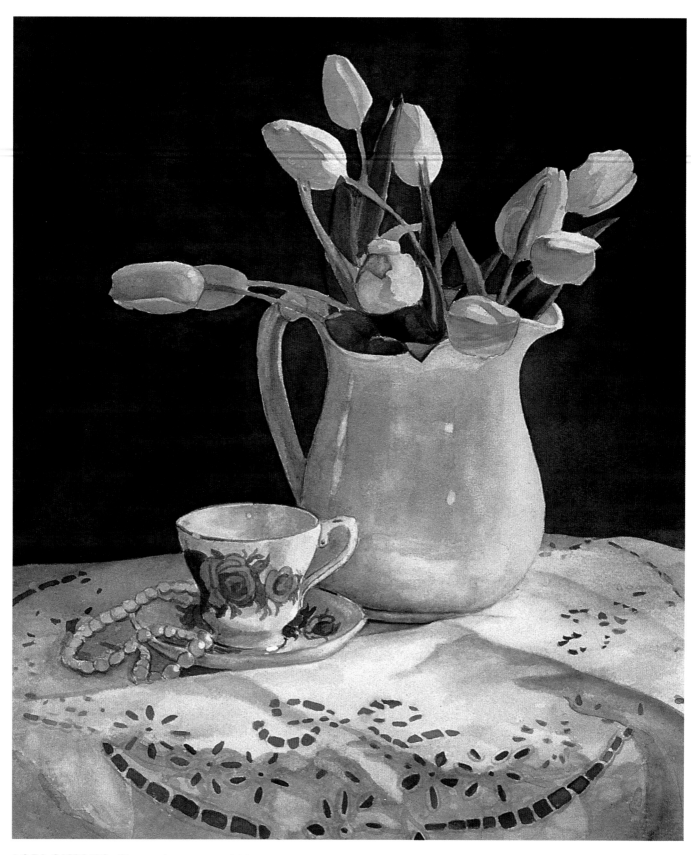

LORI SIMONS *(See template on page 120.)*

Wall

2 parts ultramarine blue +
1 part burnt umber +
1 dot blue-violet

Tablecloth shadows

1 part Payne's gray +
1 part ultramarine blue

Tulip pink

1 part crimson +
1 dot Indian yellow

Tulip orange

1 part Indian yellow +
1 part magenta

Tulip purple

1 part Payne's gray +
1 part blue-violet

Tulip yellow

1 part lemon yellow +
1 dot burnt sienna

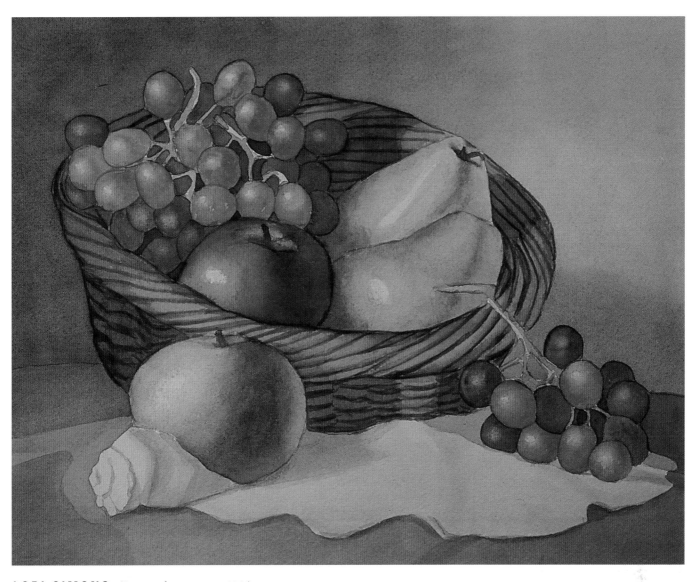

LORI SIMONS *(See template on page 121.)*

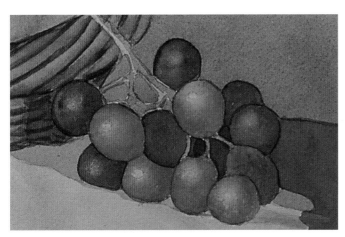

Grape detail

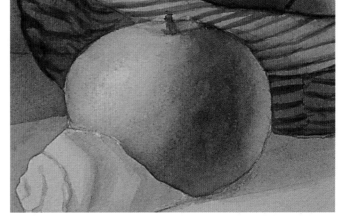

Apple detail

Basket

1 part burnt sienna +
1 dot magenta

Grape lights

1 part crimson +
1 dot lemon yellow

Grape darks

1 part crimson +
1 dot ultramarine blue

Apple yellow

1 part lemon yellow +
1 dot Naples yellow

Apple green

2 parts burnt sienna +
1 part lemon yellow +
1 part sap green

Apple darks

1 part burnt sienna +
1 part burnt umber +
1 part lemon yellow +
1 part sap green

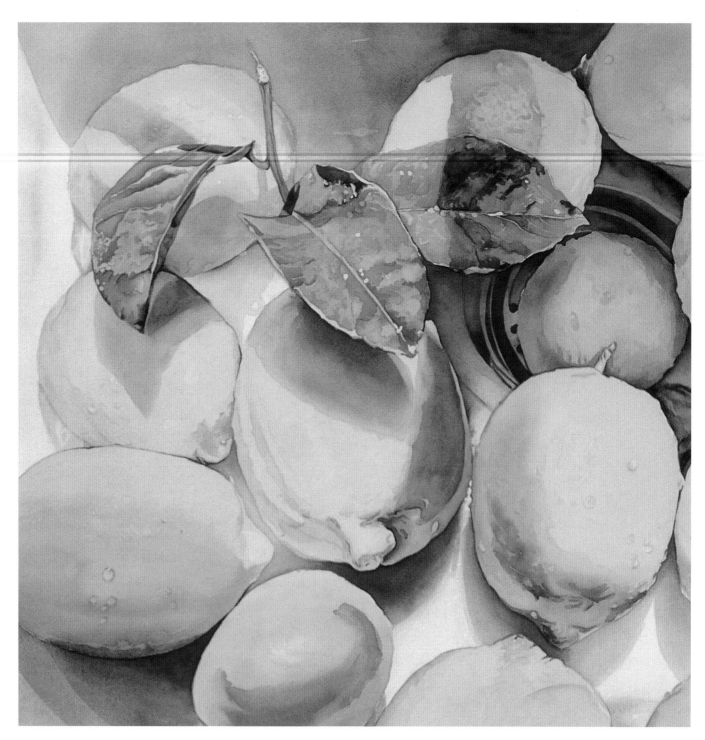

MARY KAY WILSON *(See template on page 122.)*

Lemon midtones

1 part lemon yellow +
1 part Naples yellow

Lemon light shadows

1 part lemon yellow +
1 part Naples yellow +
1 dot ultramarine blue

Lemon midtone shadows

1 part ultramarine blue +
1 part lemon yellow +
1 part Naples yellow

Lemon dark shadows

2 parts ultramarine blue +
1 part lemon yellow

Lemon orange

1 part lemon yellow +
1 part burnt sienna

Lemon red

1 part lemon yellow +
1 part burnt sienna +
1 part crimson

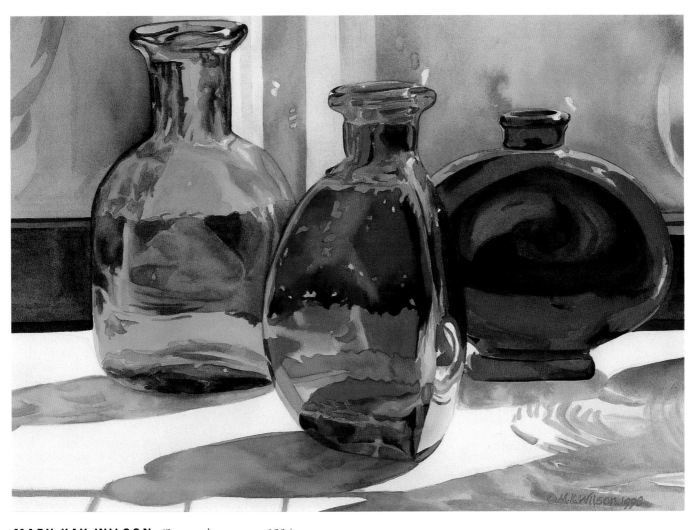

MARY KAY WILSON *(See template on page 123.)*

Yellow bottle midtones	*Yellow bottle shadows*	*Red bottle midtones*	*Red bottle shadows*	*Blue bottle midtones*	*Blue bottle shadows*
1 part burnt sienna + 1 part Indian yellow + 1 part Naples yellow	1 part crimson + 1 part burnt sienna + 2 dots burnt umber	1 part crimson + 1 dot burnt sienna + 1 dot lemon yellow	2 parts crimson + 1 dot Payne's gray	1 part ultramarine blue + 1 dot Naples yellow	2 parts ultramarine blue + 1 part Payne's gray

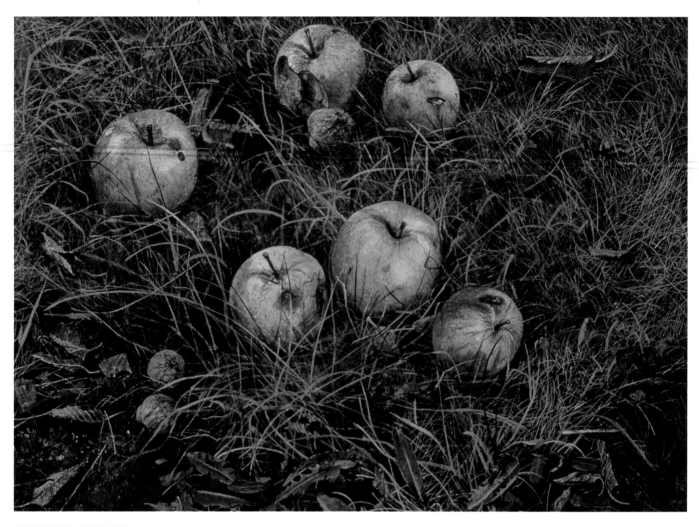

MARTIN TAYLOR

Grass	*Apple red*	*Apple yellow-green*	*Apple green*	*Apple yellow*	*Apple orange*
1 part sap green + 1 dot ultramarine blue + 1 dot crimson	1 part crimson + 1 dot burnt sienna + 1 dot lemon yellow	2 parts lemon yellow + 1 dot ultramarine blue	1 part ultramarine blue + 1 part crimson + 1 part sap green	3 parts lemon yellow + 1 dot burnt umber	1 part Naples yellow + 1 dot crimson + 1 dot burnt umber

COLOR MIXES FOR PAGE 67

Yellow lights	*Yellow midtones*	*Yellow darks*	*Tablecloth shadows*	*Fence darks*	*Blue flowers*
1 part lemon yellow + 1 part Naples yellow + 1 dot Indian yellow	1 part burnt sienna + 1 part Indian yellow + 1 part Naples yellow	1 part burnt sienna + 1 dot lemon yellow + 1 dot crimson	2 parts blue-violet + 2 parts ultramarine blue + 1 part burnt umber	1 part magenta + 1 part Payne's gray	1 part cerulean blue + 1 part ultramarine blue + 1 part crimson

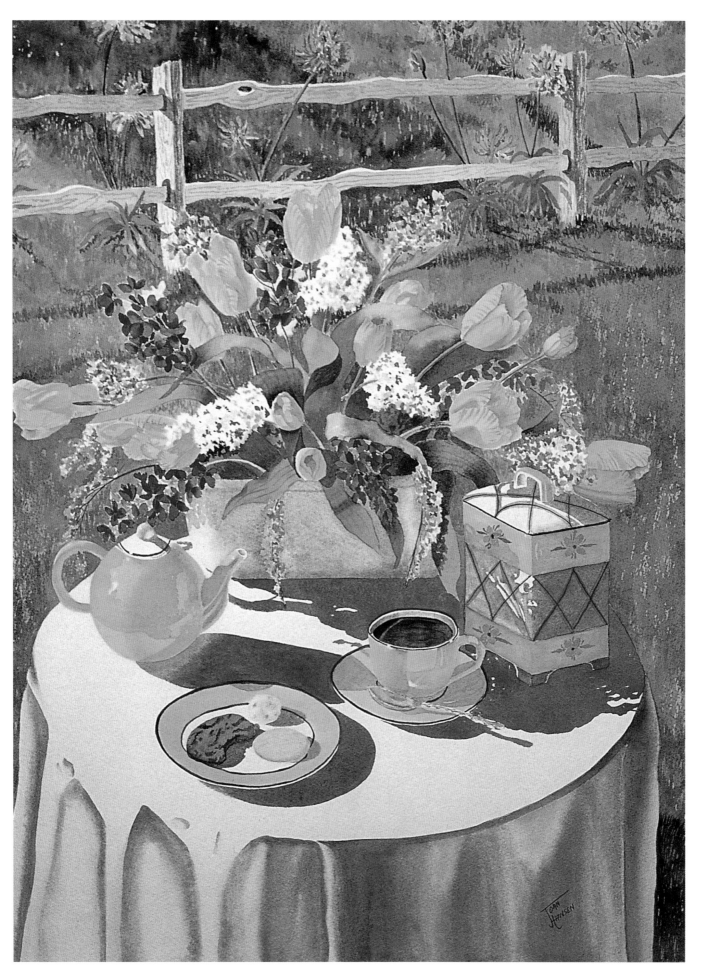

JOAN HANSEN *(See template on page 124. See color mixes on page 66.)*

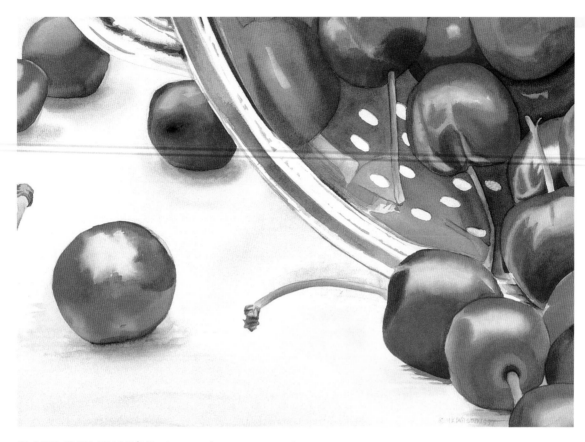

Cherry reflections

1 part Naples yellow +
1 dot crimson +
1 dot burnt umber

Cherry midtones

1 part crimson +
1 dot burnt sienna

Cherry stems

1 part sap green +
1 dot Naples yellow +
1 dot burnt umber

MARY KAY WILSON *(See template on page 125.)*

Tablecloth

1 part ultramarine blue +
1 part cerulean blue

Cherry midtones

1 part crimson +
1 dot burnt sienna

Cherry darks

1 part crimson +
1 dot Payne's gray +
1 dot burnt umber

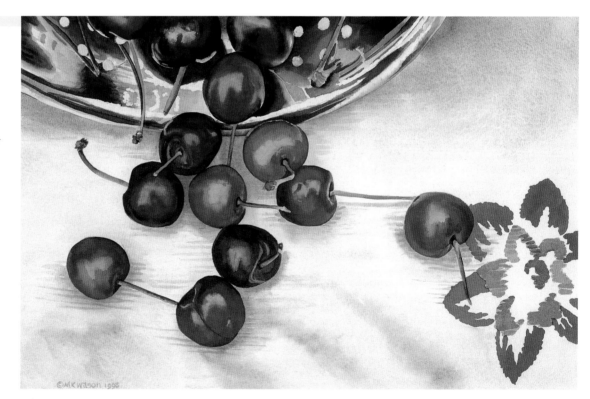

MARY KAY WILSON *(See template on page 126.)*

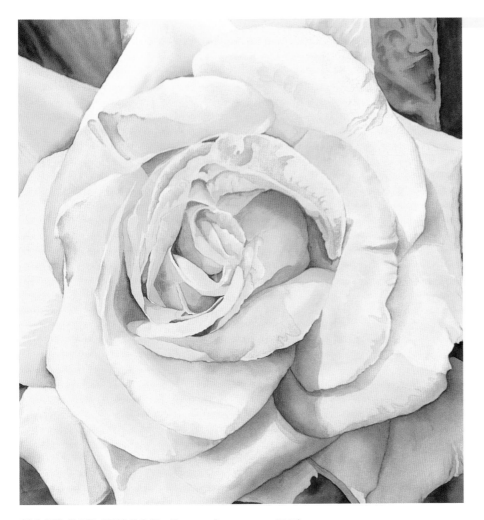

Flower lights

1 part lemon yellow +
1 part Naples yellow

Flower orange

1 part Naples yellow +
1 part Indian yellow +
1 dot crimson

Flower purple

1 part Payne's gray +
1 part blue-violet

Flower pink

2 parts Naples yellow +
1 part magenta +
1 dot ultramarine blue

Leaf midtones

1 part lemon yellow +
1 dot Payne's gray +
1 dot Hooker's green

Leaf darks

1 Payne's gray +
1 dot lemon yellow +
1 dot Hooker's green

MARY KAY WILSON *(See template on page 127.)*

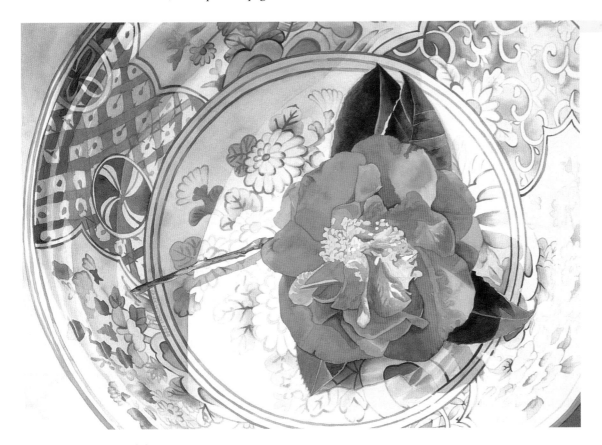

Flower lights

1 part crimson +
1 dot Indian yellow

Flower darks

1 part crimson +
1 dot lemon yellow

Flower orange

1 part lemon yellow +
1 part Naples yellow +
1 dot crimson

MARY KAY WILSON

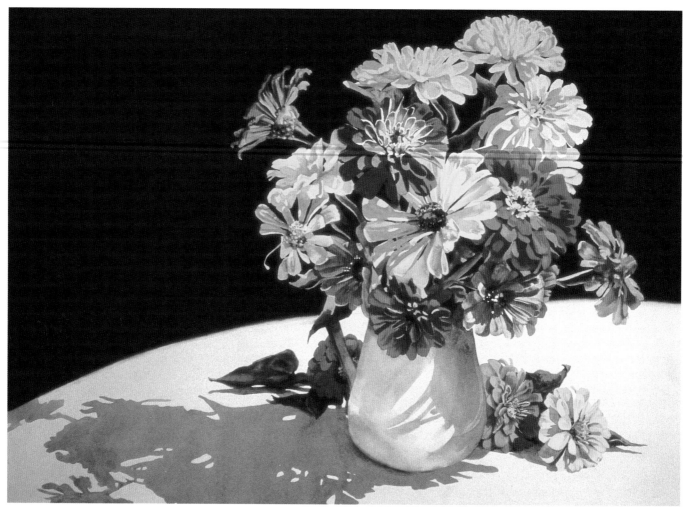

JOAN ROTHEL *(See template on page 128.)*

*Yellow
flower midtones*

1 part lemon yellow +
1 dot crimson +
1 dot burnt sienna

Yellow flower darks

1 part lemon yellow +
1 dot burnt sienna

*Red flower
midtones*

1 part crimson +
1 dot Indian yellow +
1 dot burnt umber

Red flower darks

1 part Naples yellow +
1 part crimson +
1 part burnt sienna +
1 dot Payne's gray

*Orange
flower midtones*

Burnt sienna

*Orange flower
darks*

1 part burnt sienna +
1 dot Naples yellow +
1 dot crimson

*Purple
flower midtones*

1 part crimson +
1 dot blue-violet

Purple flower darks

1 part magenta +
1 dot Payne's gray

*Flower
stem midtones*

2 parts ultramarine blue +
2 parts sap green +
1 part burnt umber

*Flower
stem darks*

1 part ultramarine blue +
1 part crimson +
1 part sap green

Wall

1 part ultramarine blue +
1 part burnt sienna +
1 part Payne's gray

Vase cast shadow

1 part burnt sienna +
1 part crimson +
1 part cerulean blue +
1 part ultramarine blue

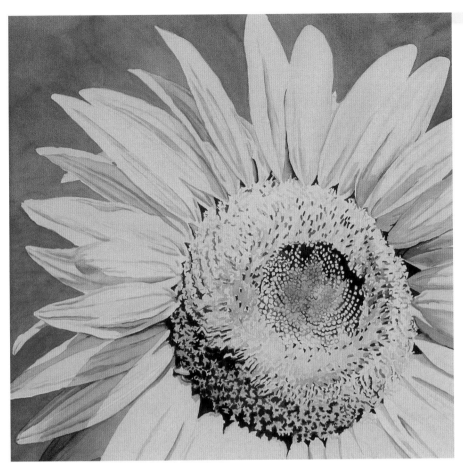

Background

1 part ultramarine blue +
1 part cerulean blue +
1 dot burnt umber +
1 dot blue-violet

Flower midtones

1 part burnt sienna +
1 dot Naples yellow +
1 dot crimson

*Flower
dark shadows*

2 parts crimson +
1 part sap green +
1 part ultramarine blue

*Flower
blue shadows*

1 part ultramarine blue +
1 dot burnt sienna +
1 dot cerulean blue

Flower orange

1 part burnt sienna +
1 dot burnt umber +
1 dot crimson

Flower gray shadows

1 part cerulean blue +
1 part burnt sienna +
1 dot magenta

MARY KAY WILSON *(See template on page 129.)*

Flower lights

1 part crimson +
1 dot blue-violet

Flower midtones

1 part crimson +
1 dot blue-violet +
1 dot ultramarine blue

Flower darks

1 part magenta +
2 dots cerulean blue +
1 dot burnt umber

Flower shadows

1 part blue-violet +
1 dot Naples yellow

Flower orange

1 part lemon yellow +
1 part burnt sienna +
1 part crimson

Flower yellow

1 part lemon yellow +
1 dot crimson +
1 dot burnt sienna

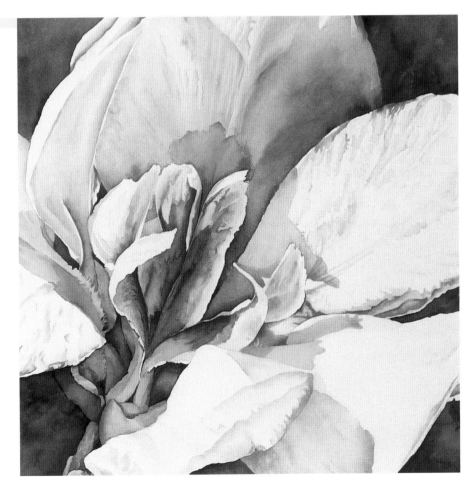

MARY KAY WILSON *(See template on page 130.)*

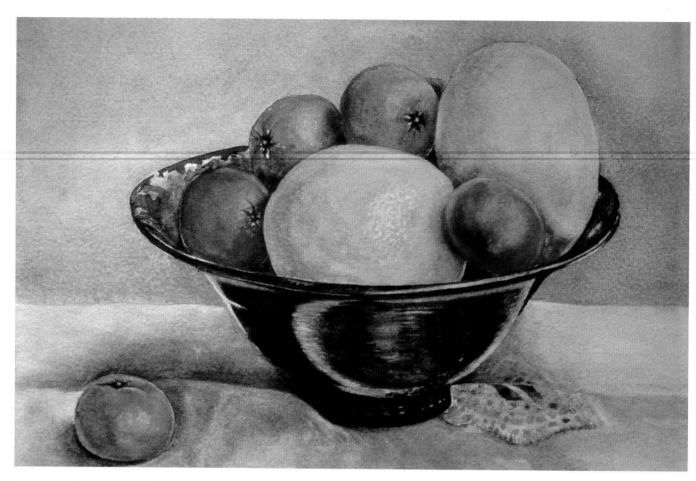

DOREEN BARTLETT *(See template on page 131.)*

Foreground blue	*Foreground purple*	*Lemons*	*Lemon shadows*	*Orange midtones*	*Orange darks*
1 part ultramarine blue + 1 dot Payne's gray	2 parts ultramarine blue + 1 part Payne's gray + 1 part blue-violet	1 part lemon yellow + 1 dot Naples yellow	1 part sap green + 1 dot ultramarine blue + 1 dot crimson	1 part lemon yellow + 1 part Naples yellow + 1 dot crimson	1 part burnt sienna + 1 dot Naples yellow + 1 dot crimson

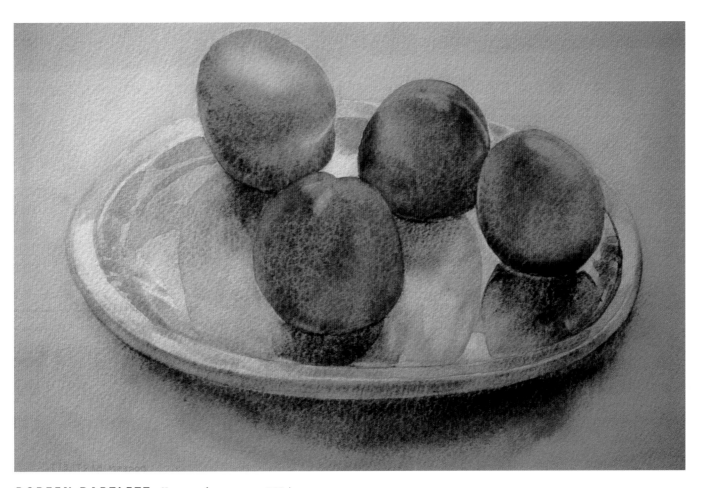

DOREEN BARTLETT *(See template on page 131.)*

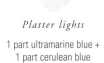

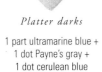

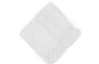

Platter lights	*Platter darks*	*Fruit yellow-orange*	*Fruit brown*	*Fruit midvalues*	*Fruit shadows*
1 part ultramarine blue + 1 part cerulean blue	1 part ultramarine blue + 1 dot Payne's gray + 1 dot cerulean blue	1 part Indian yellow + 1 dot Naples yellow + 1 dot burnt sienna	1 part burnt umber + 1 dot crimson + 1 dot Payne's gray	1 part lemon yellow + 1 part burnt sienna + 1 part crimson	2 parts Payne's gray + 1 part burnt umber

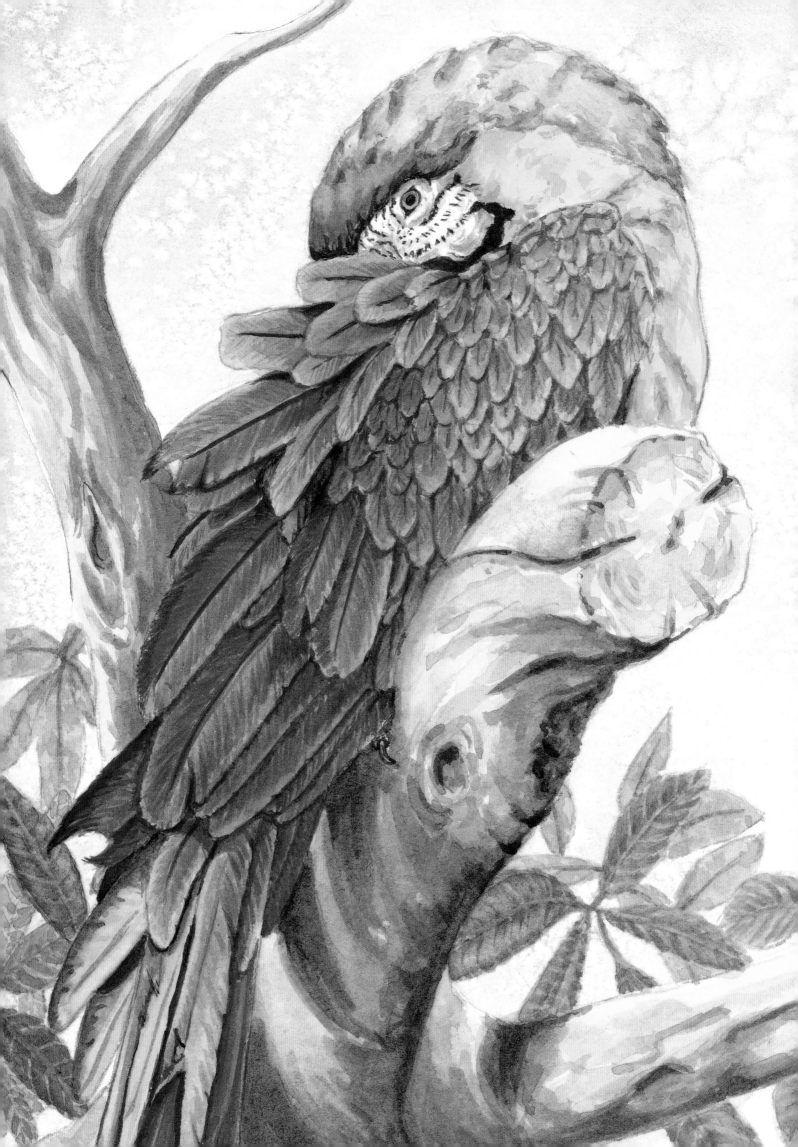

CHAPTER 5

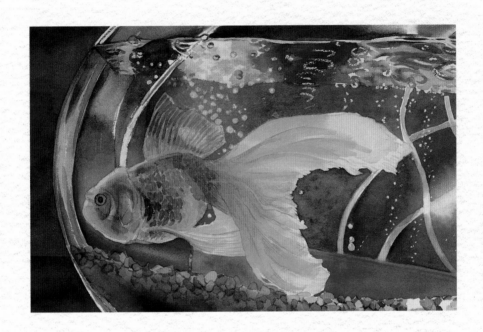

Animals

Fur brown

1 part burnt sienna +
1 dot crimson

Fur light gray

1 part ultramarine blue +
1 part burnt umber +
1 dot burnt sienna

Fur dark gray

1 part burnt umber +
1 part ultramarine blue +
1 part sap green

Iris

1 part Hooker's green +
1 part lemon yellow +
1 part Payne's gray

Pupil

1 part Payne's gray +
1 dot Hooker's green

Inner ear

1 part crimson +
1 part Naples yellow +
1 dot lemon yellow

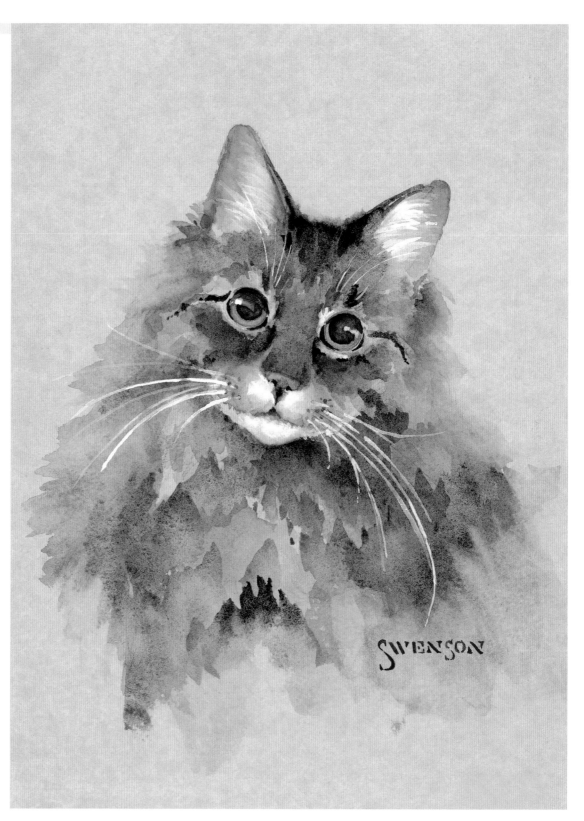

BRENDA SWENSON

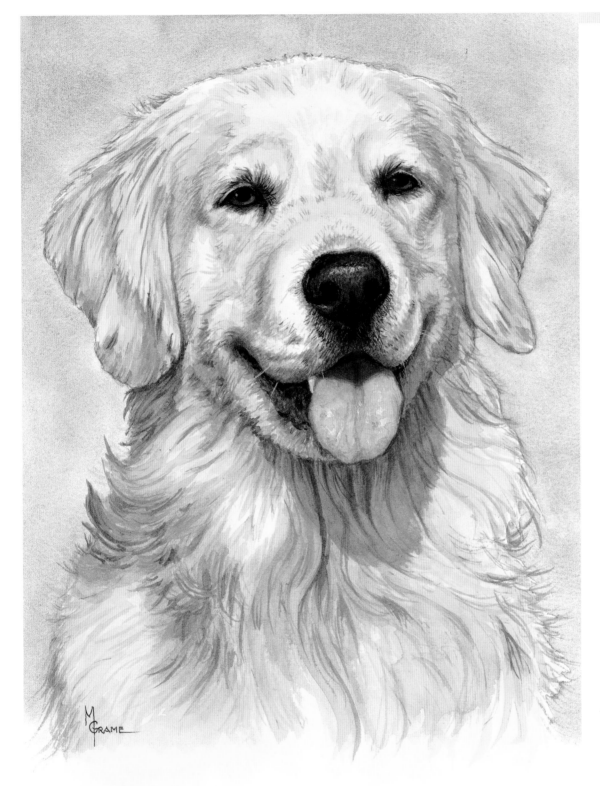

Fur lights

1 part Naples yellow +
1 dot burnt sienna

Fur midtones

1 part burnt umber +
1 part Naples yellow

Fur darks

1 part burnt sienna +
1 dot lemon yellow +
1 dot crimson

Fur shadows

1 part burnt umber +
1 dot burnt sienna

Nose

Payne's gray

Tongue

1 part crimson +
1 dot Naples yellow

MARILYN GRAME *(See template on page 132.)*

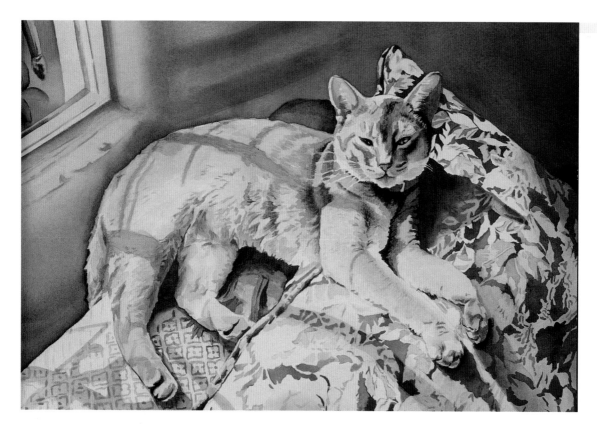

Fur lights

1 part burnt sienna +
1 part lemon yellow

Fur darks

1 part burnt sienna +
1 dot lemon yellow

Fur shadows

1 part burnt sienna +
1 dot blue-violet

MARY KAY WILSON *(See template on page 133.)*

Fish bowl bottom

1 part ultramarine blue +
1 part cerulean blue +
1 dot Payne's gray

Water darks

1 part cerulean blue +
1 part Payne's gray +
1 dot ultramarine blue

Water blue-green

1 part cerulean blue +
1 dot burnt umber +
1 dot Payne's gray

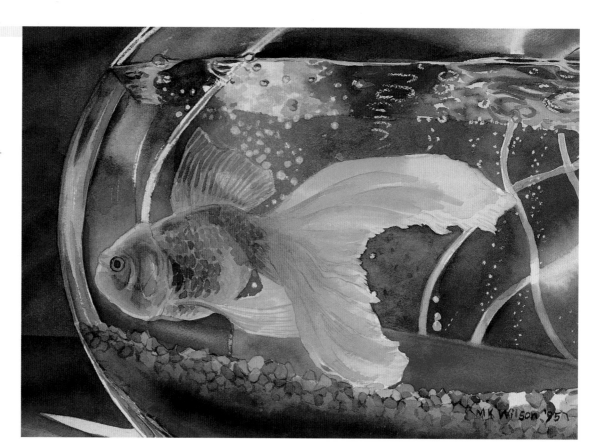

MARY KAY WILSON *(See template on page 134.)*

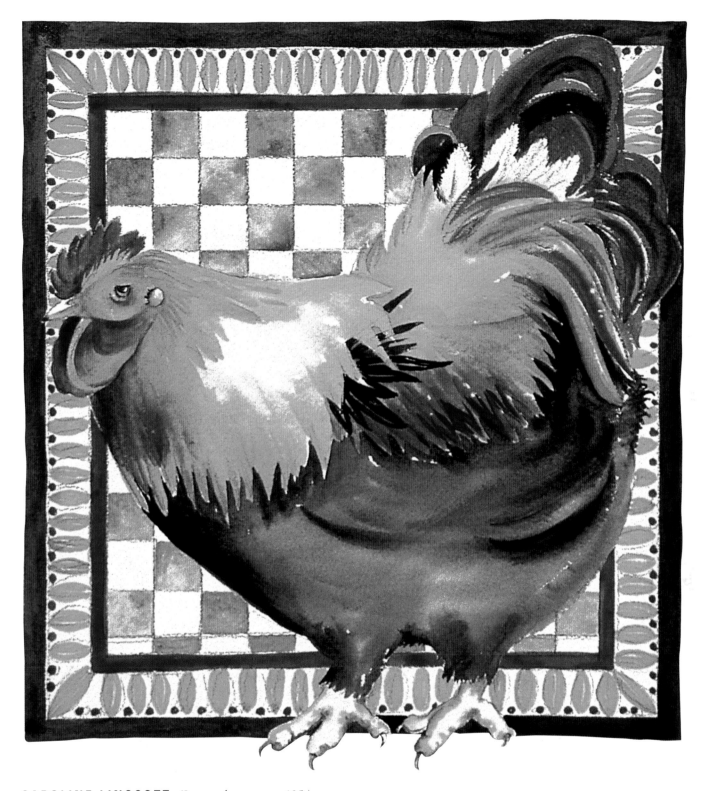

CAROLINE LINSCOTT *(See template on page 135.)*

Yellow feathers

1 part lemon yellow +
1 dot burnt umber +
1 dot burnt sienna

Red feather midtones

2 parts lemon yellow +
1 part magenta

Red feather shadows

2 parts lemon yellow +
1 part magenta +
1 part Payne's gray

Blue feather shadows

1 part ultramarine blue +
1 dot burnt sienna +
1 dot crimson

Blue feather midtones

1 part ultramarine blue +
1 dot burnt sienna +
1 dot crimson +
more water

Checker pattern

1 part sap green +
1 dot Payne's gray +
1 dot ultramarine blue

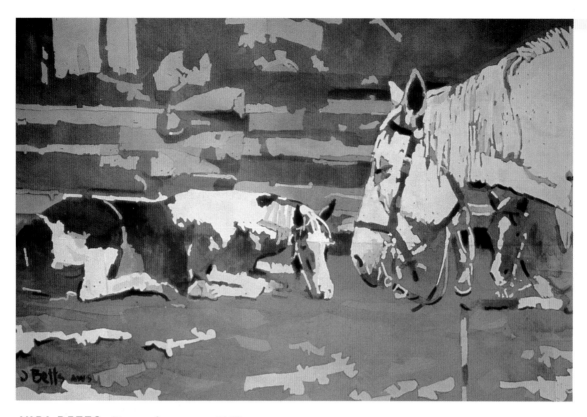

JUDI BETTS *(See template on page 136.)*

Light brown glaze

1 part burnt sienna +
1 part Naples yellow +
1 dot crimson

Dark brown glaze

1 part burnt umber +
1 dot Payne's gray

Light green glaze

1 part cerulean blue +
1 part lemon yellow

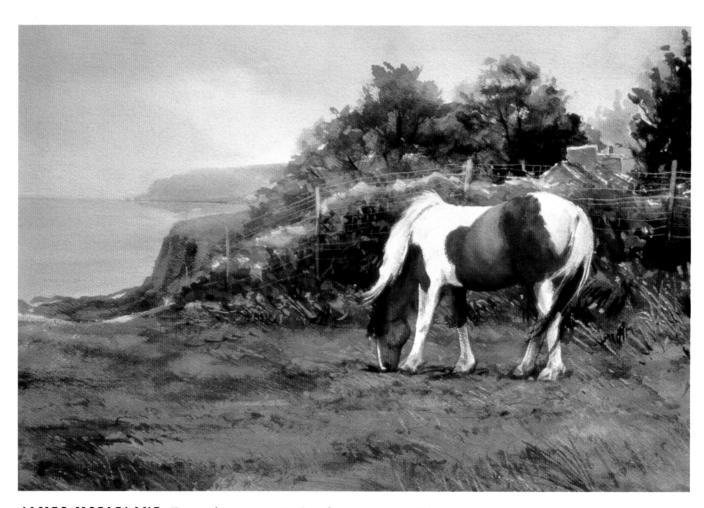

JAMES MCFARLANE *(See template on page 137. See color mixes on page 81.)*

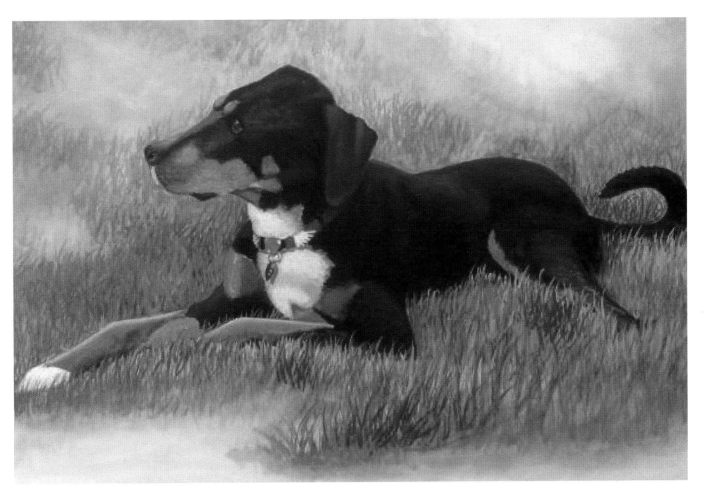

KEN GOLDMAN *(See template on page 138.)*

Brown fur	*Black fur*	*Black fur accents*	*White fur shadows*	*Grass blue-green*	*Grass yellow*
1 part burnt sienna + 1 dot burnt umber + 1 dot crimson	1 part Payne's gray + 1 dot blue-violet + 1 dot ultramarine blue	1 part cerulean blue + 1 dot ultramarine blue + 1 dot Payne's gray	1 part ultramarine blue + 1 part cerulean blue	1 part cerulean blue + 1 part lemon yellow + 1 dot magenta	2 parts lemon yellow + 1 dot Indian yellow

COLOR MIXES FOR PAGE 80, BOTTOM PAINTING

Ground lights	*Ground darks*	*Horse lights*	*Horse darks*	*Tree lights*	*Tree darks*
1 part burnt umber + 1 part Naples yellow + 1 dot lemon yellow + 1 dot Payne's gray	1 part burnt umber + 1 dot Payne's gray + 1 dot Naples yellow	1 part Naples yellow + 1 dot burnt umber + 1 dot lemon yellow	1 part crimson + 1 part burnt umber	1 part Payne's gray + 1 dot cerulean blue + 1 dot lemon yellow	2 parts Payne's gray + 1 part burnt umber

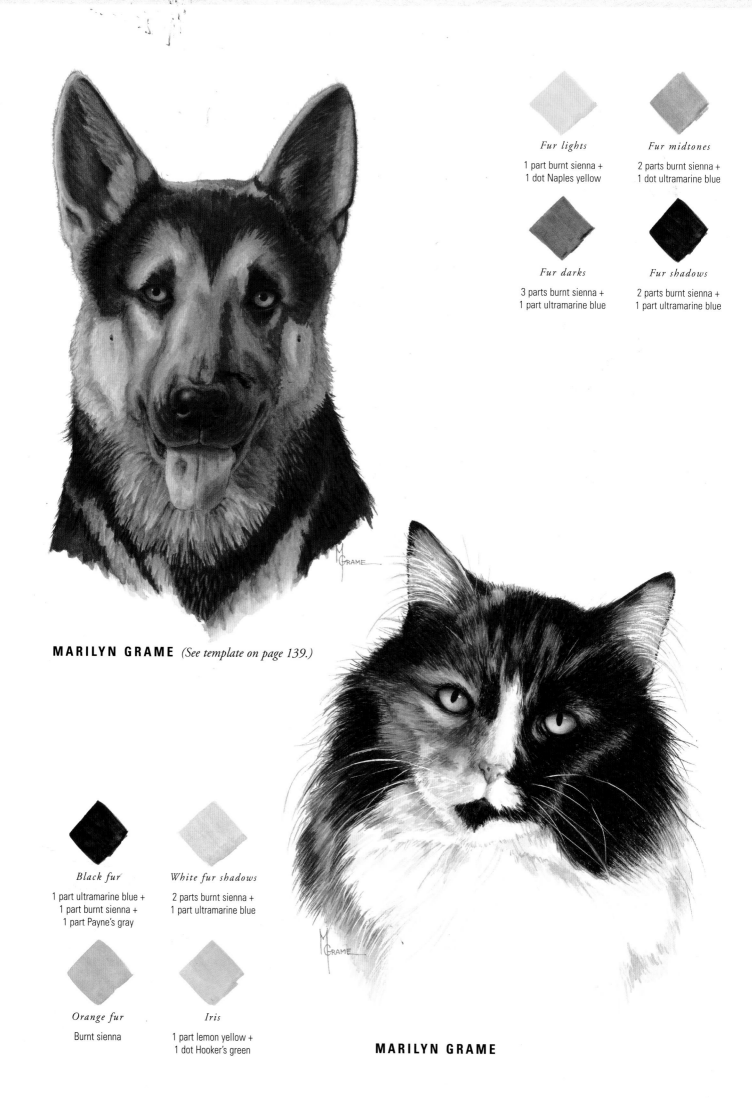

Fur lights

1 part burnt sienna +
1 dot Naples yellow

Fur midtones

2 parts burnt sienna +
1 dot ultramarine blue

Fur darks

3 parts burnt sienna +
1 part ultramarine blue

Fur shadows

2 parts burnt sienna +
1 part ultramarine blue

MARILYN GRAME *(See template on page 139.)*

Black fur

1 part ultramarine blue +
1 part burnt sienna +
1 part Payne's gray

White fur shadows

2 parts burnt sienna +
1 part ultramarine blue

Orange fur

Burnt sienna

Iris

1 part lemon yellow +
1 dot Hooker's green

MARILYN GRAME

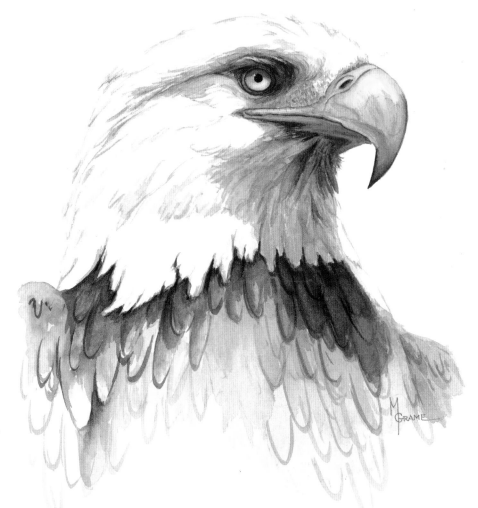

Beak

1 part lemon yellow +
1 part Naples yellow +
1 part Indian yellow

Feather lights

2 parts burnt sienna +
1 dot ultramarine blue

Feather darks

2 parts burnt sienna +
1 dot ultramarine blue +
1 dot Payne's gray

Feather shadows

2 parts burnt sienna +
1 part ultramarine blue

MARILYN GRAME *(See template on page 140.)*

Yellow feathers

2 parts lemon yellow +
1 dot sap green

Blue feathers

1 part ultramarine blue +
1 dot crimson

Green feathers

1 part lemon yellow +
1 dot Payne's gray +
1 dot Hooker's green

Green feather shadows

1 part Payne's gray +
1 dot lemon yellow +
1 dot Hooker's green

Red feathers

1 part crimson +
1 dot Indian yellow

Red feather shadows

1 part crimson +
1 part Payne's gray +
1 dot Indian yellow

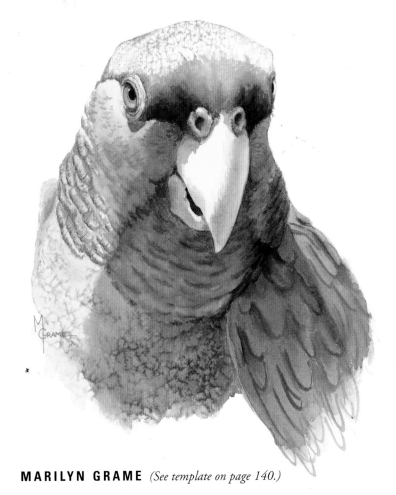

MARILYN GRAME *(See template on page 140.)*

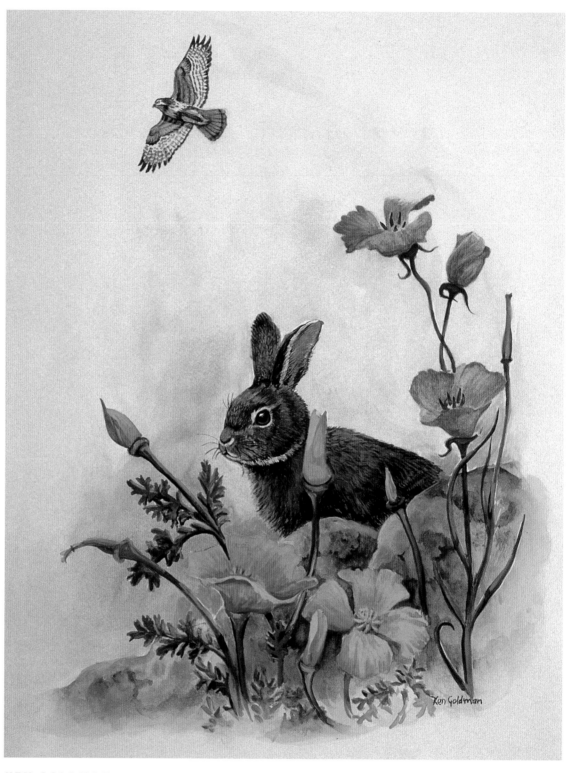

KEN GOLDMAN

Sky

1 part cerulean blue +
1 dot ultramarine blue +
1 dot Payne's gray

Fur lights

1 part burnt sienna +
1 dot burnt umber +
1 dot crimson

Fur darks

2 parts burnt sienna +
1 dot ultramarine blue +
1 dot Payne's gray

Orange flowers

1 part Indian yellow +
1 dot crimson

Orange flower shadows

1 part crimson +
1 part Indian yellow +
1 dot lemon yellow

Pink flowers

1 part crimson +
1 dot magenta

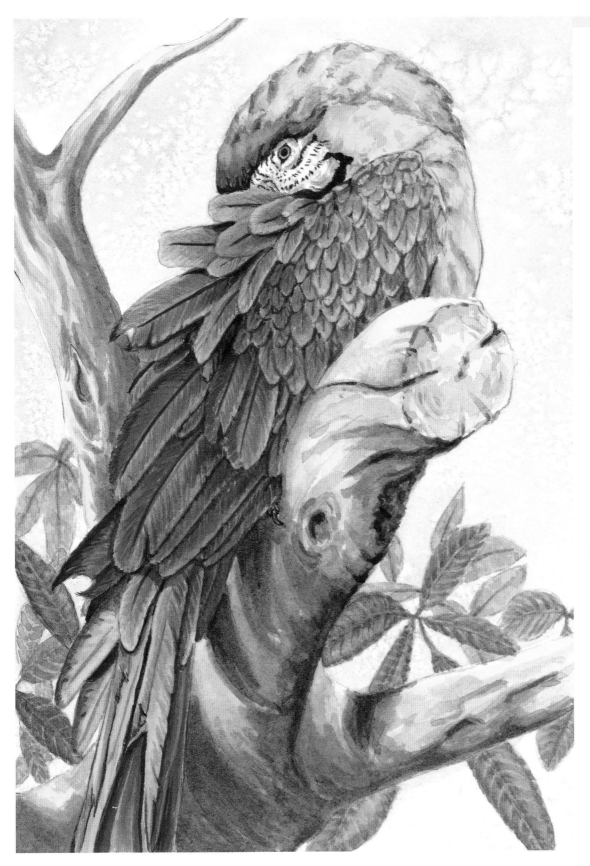

Blue feather lights

2 parts cerulean blue +
1 part ultramarine blue

Blue feather darks

1 part ultramarine blue +
1 part cerulean blue

Blue feather shadows

2 parts ultramarine blue +
1 part Payne's gray

Green feather lights

1 part lemon yellow +
1 dot sap green

Green feather darks

1 part Hooker's green +
1 part lemon yellow

*Green feather
shadows*

1 part Hooker's green +
1 part Payne's gray

MARILYN GRAME *(See template on page 141.)*

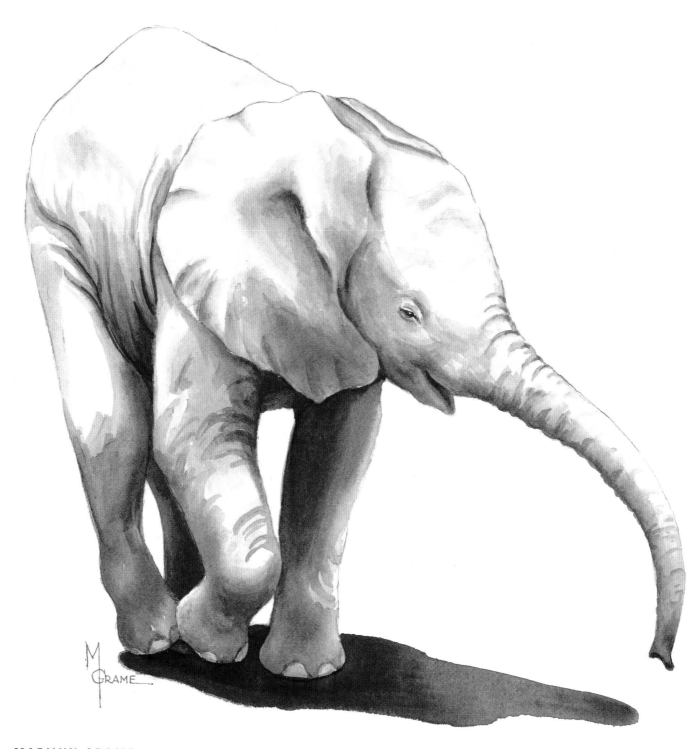

MARILYN GRAME *(See template on page 142.)*

Hide brown

2 parts burnt sienna +
1 dot ultramarine blue

Hide shadows

2 parts burnt sienna +
1 part ultramarine blue

Hide midtones

2 parts burnt sienna +
1 part ultramarine blue +
more water

Hide lights

2 parts burnt sienna +
1 part ultramarine blue +
more water

*Ground
light shadows*

1 part burnt sienna +
1 dot ultramarine blue +
1 dot magenta

*Ground
dark shadows*

1 part crimson +
1 part Payne's gray +
1 dot Indian yellow

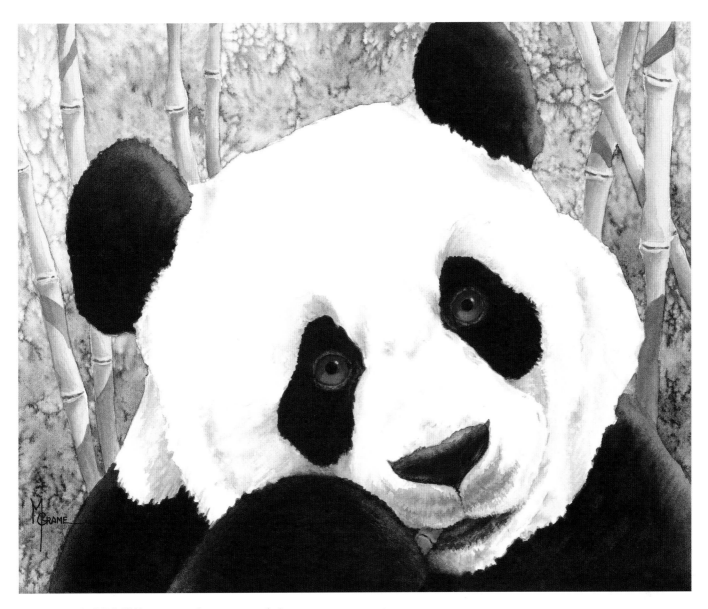

MARILYN GRAME *(See template on page 143.)*

Nose and mouth detail

Fur darks

1 part ultramarine blue +
1 part burnt sienna +
1 part Payne's gray

*White fur
dark shadows*

1 part ultramarine blue +
1 part burnt sienna +
1 part Payne's gray +
more water

*White fur
light shadows*

2 parts burnt sienna +
1 part ultramarine blue

Iris

1 part burnt sienna +
1 dot ultramarine blue +
1 dot magenta

Tongue

1 part crimson +
1 part ultramarine blue +
1 dot Payne's gray

Bamboo

1 part Naples yellow +
1 part burnt sienna

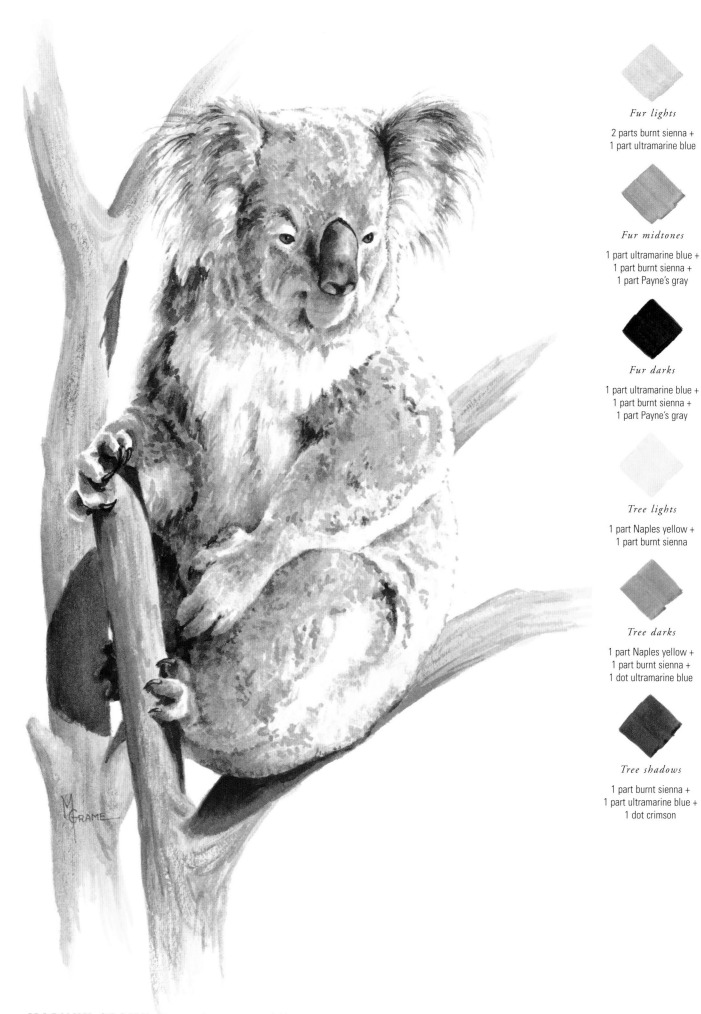

MARILYN GRAME (*See template on page 144.*)

Fur lights

2 parts burnt sienna +
1 part ultramarine blue

Fur midtones

1 part ultramarine blue +
1 part burnt sienna +
1 part Payne's gray

Fur darks

1 part ultramarine blue +
1 part burnt sienna +
1 part Payne's gray

Tree lights

1 part Naples yellow +
1 part burnt sienna

Tree darks

1 part Naples yellow +
1 part burnt sienna +
1 dot ultramarine blue

Tree shadows

1 part burnt sienna +
1 part ultramarine blue +
1 dot crimson

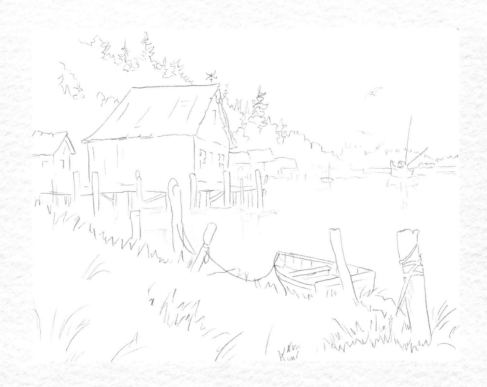

Templates

See finished painting on page 14.

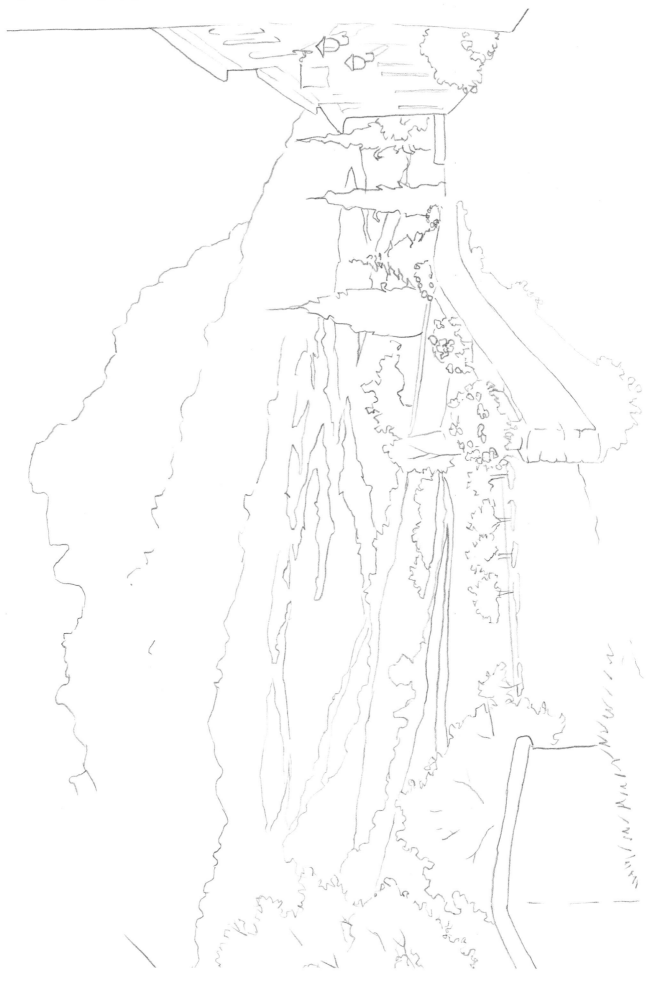

See finished painting on page 16.

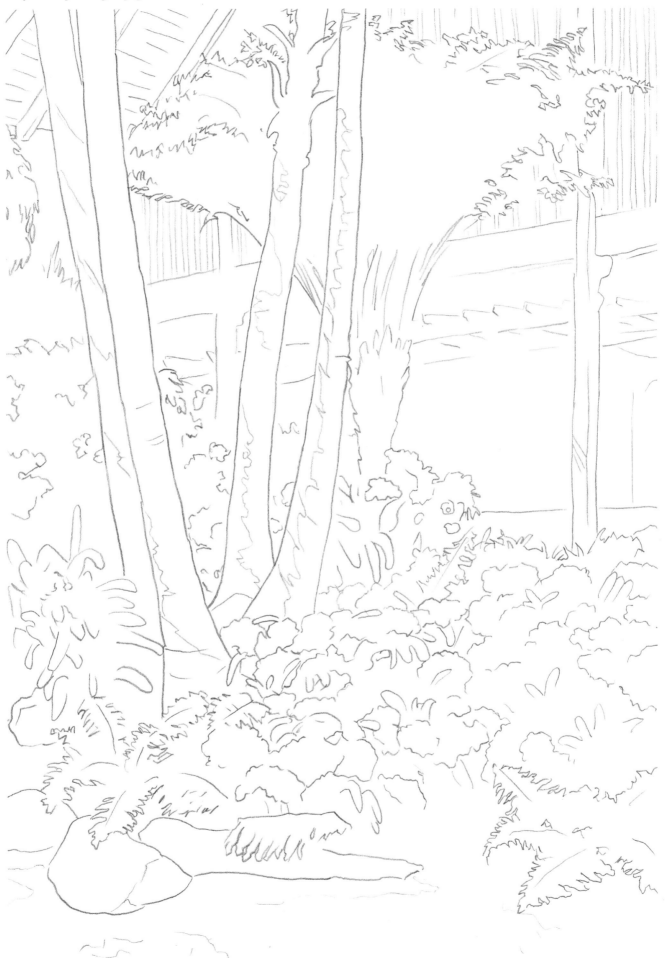

See finished painting on page 17.

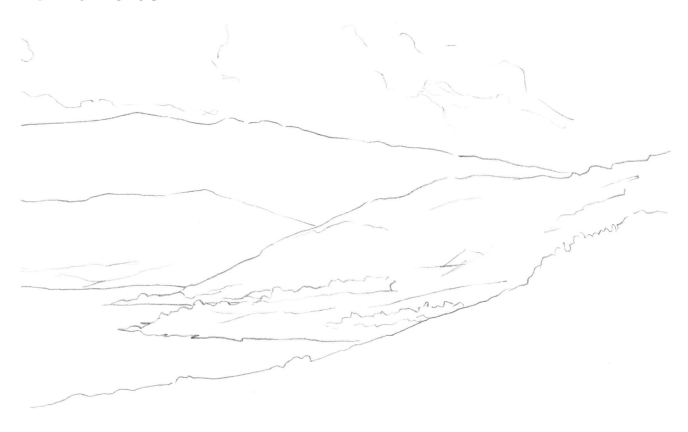

See finished painting on page 17.

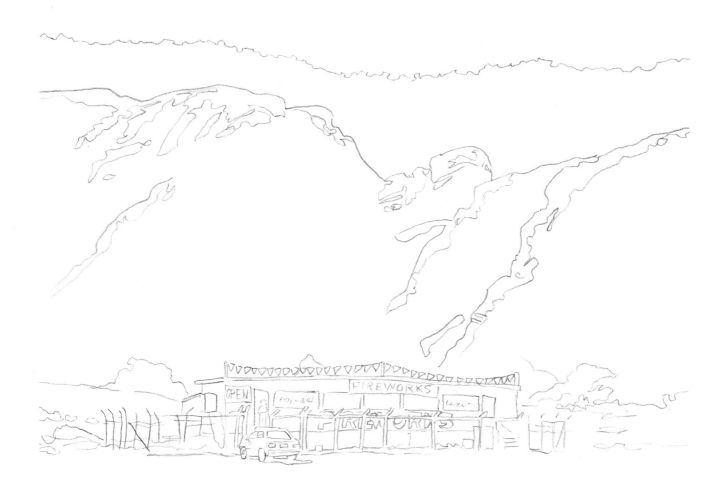

See finished painting on page 19.

See finished painting on page 21.

See finished painting on page 22.

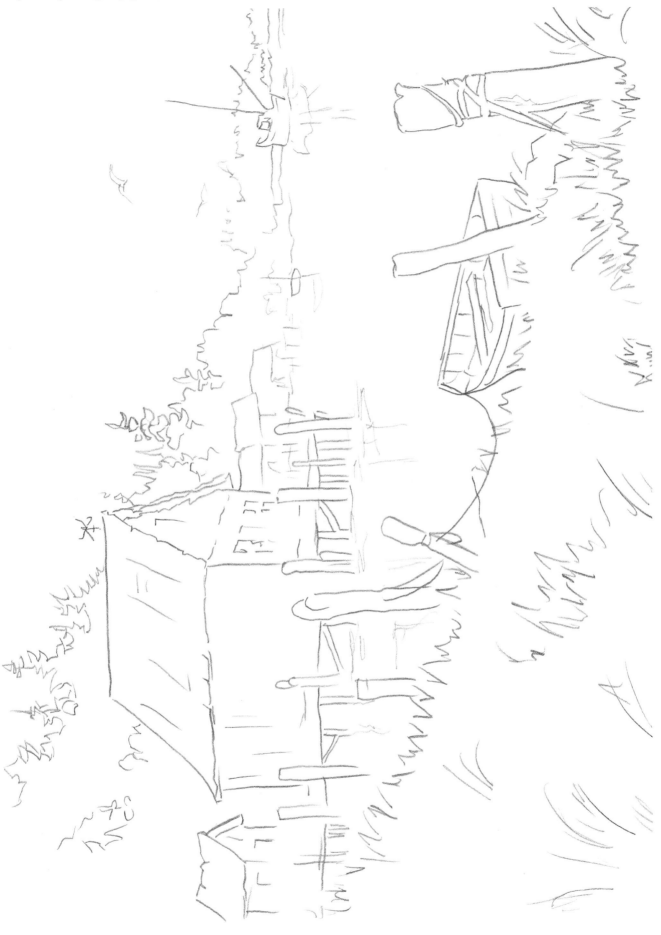

See finished painting on page 25.

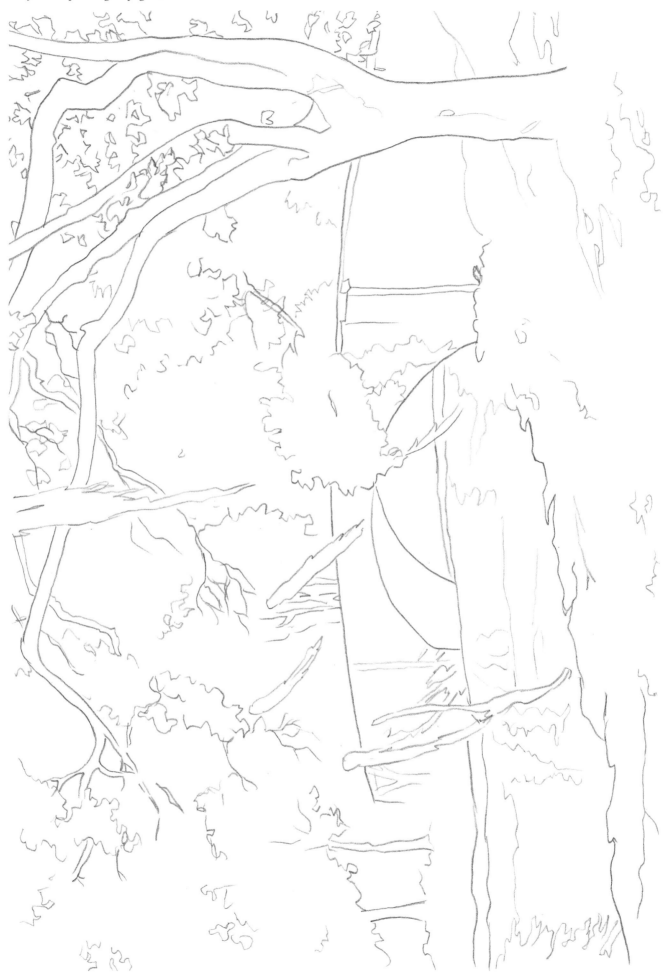

See finished painting on page 26.

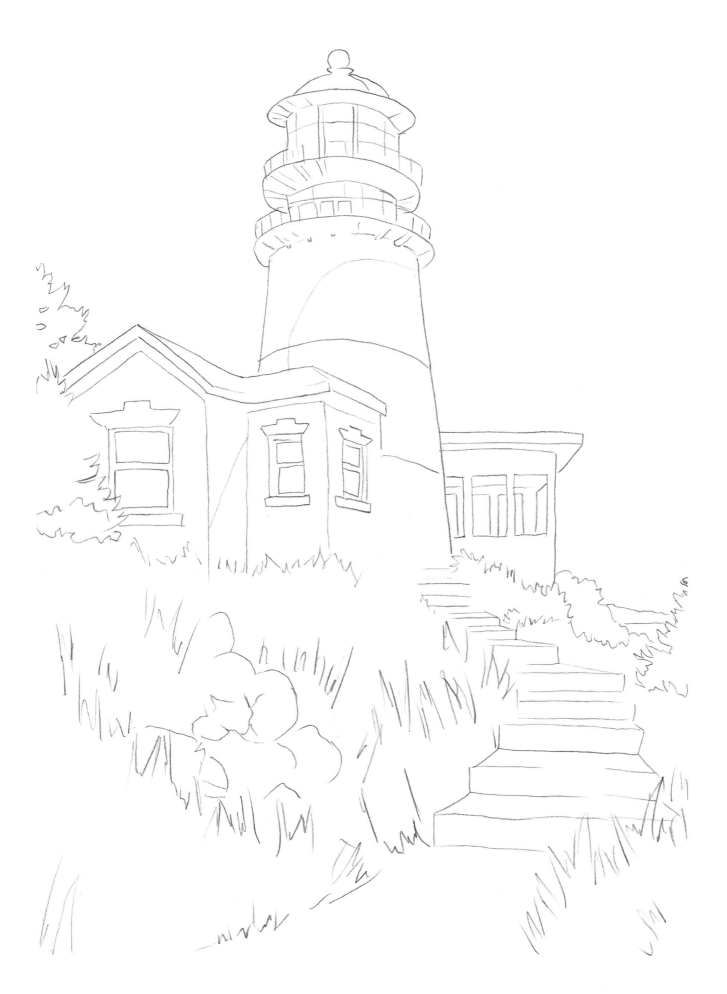

See finished painting on page 31.

See finished painting on page 32.

See finished painting on page 32.

See finished painting on page 33.

See finished painting on page 35.

See finished painting on page 35.

See finished painting on page 37.

See finished painting on page 38.

See finished painting on page 39.

See finished painting on page 39.

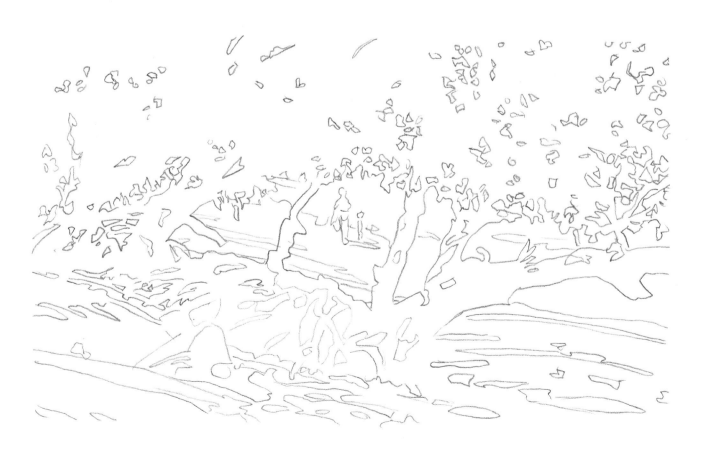

See finished painting on page 43.

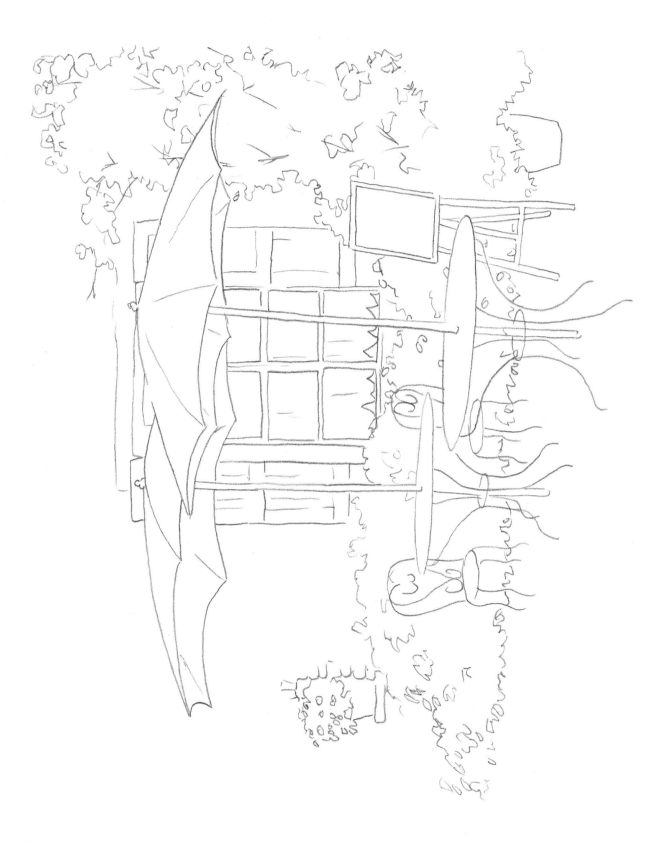

See finished painting on page 44.

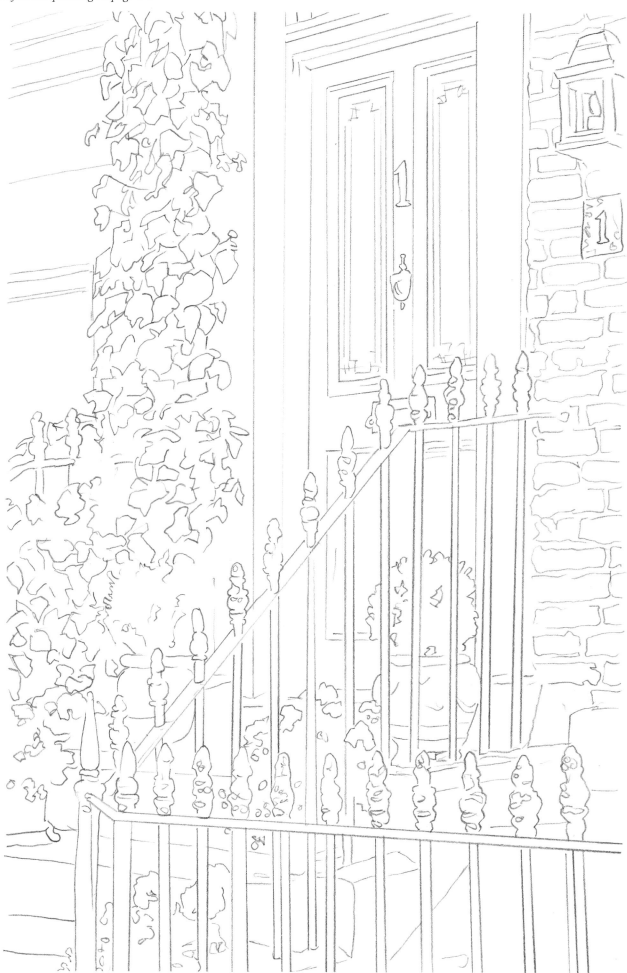

See finished painting on page 46.

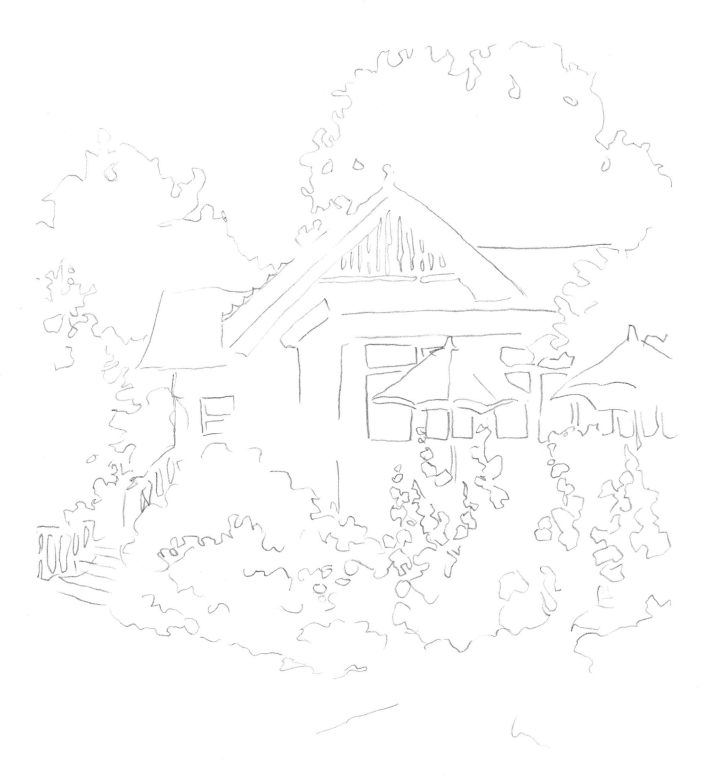

See finished painting on page 47.

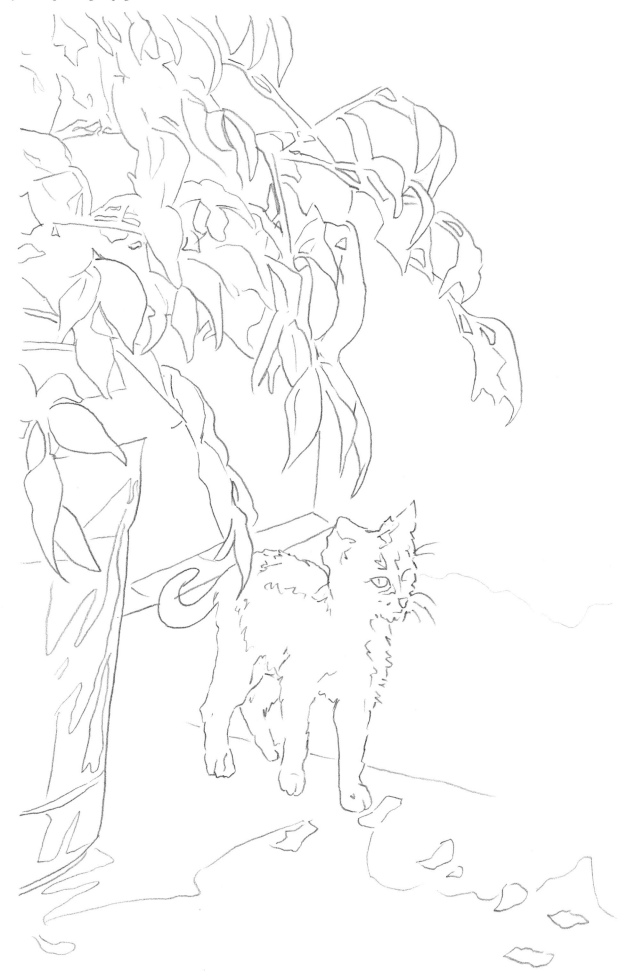

See finished painting on page 48.

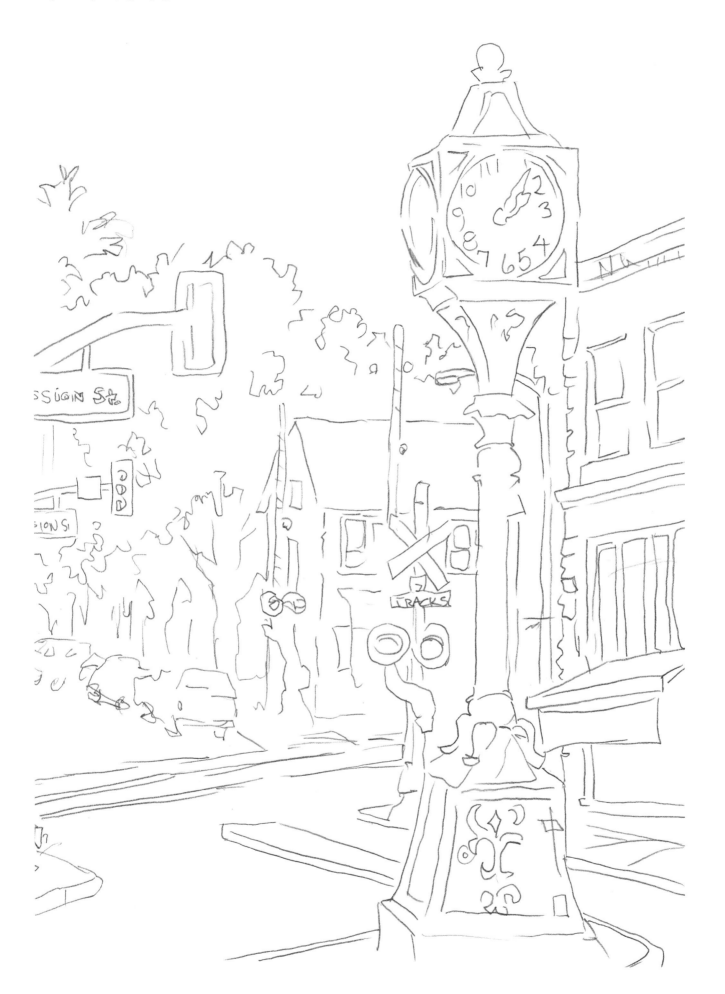

See finished painting on page 49.

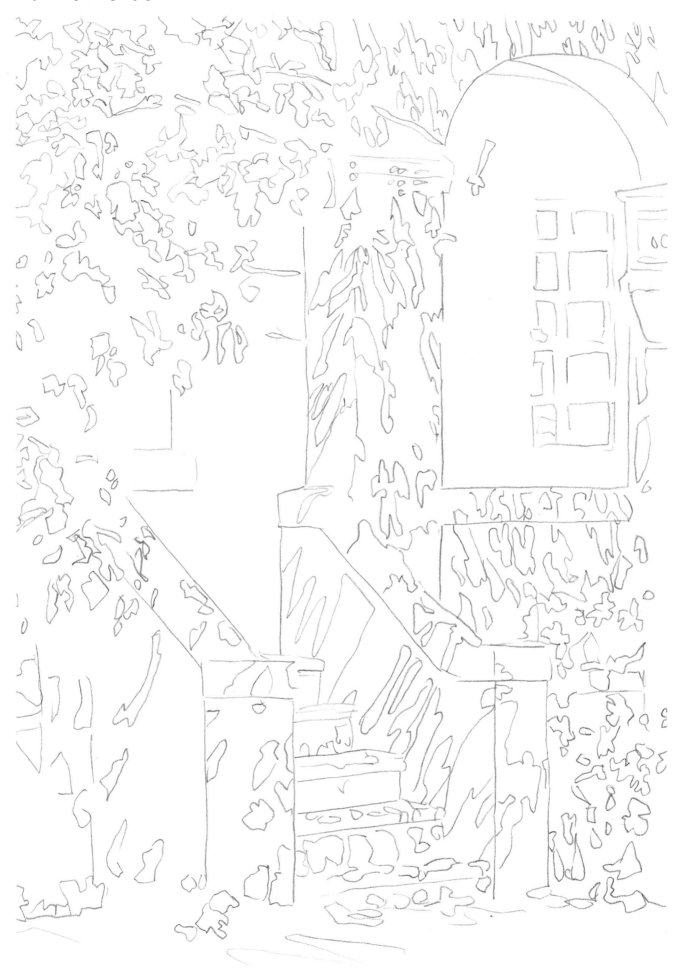

See finished painting on page 50.

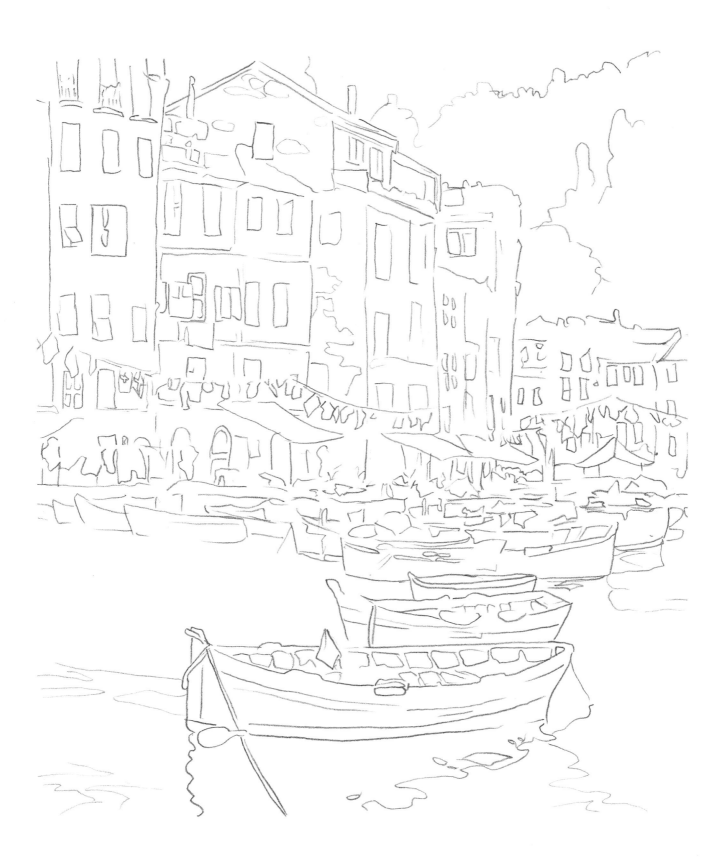

See finished painting on page 51.

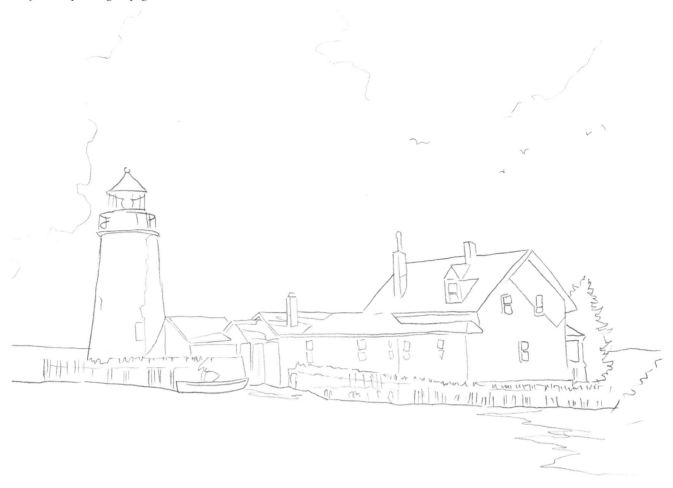

See finished painting on page 52.

See finished painting on page 53.

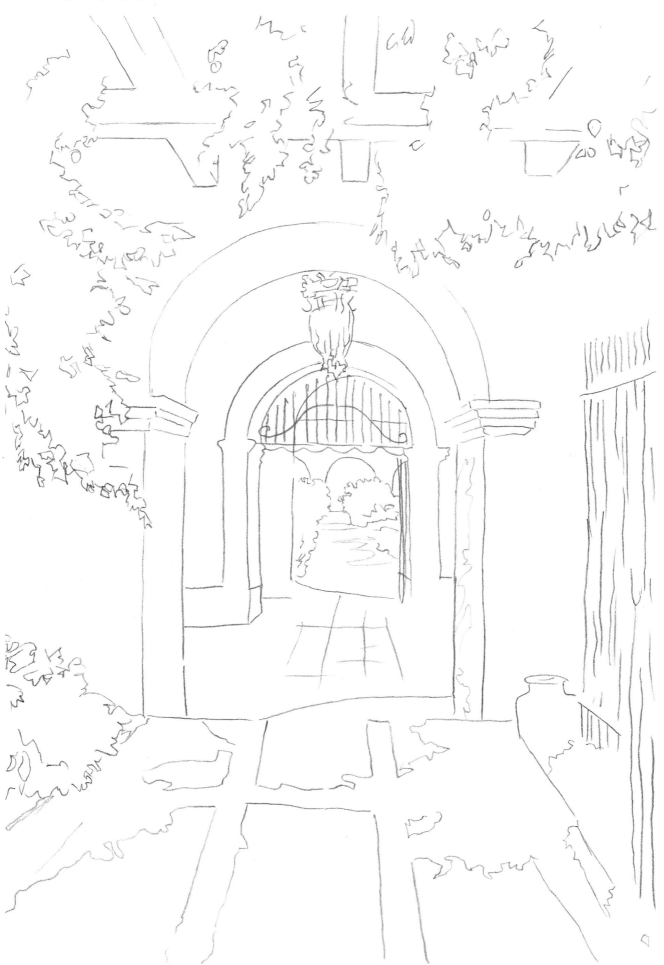

See finished painting on page 54.

See finished painting on page 56.

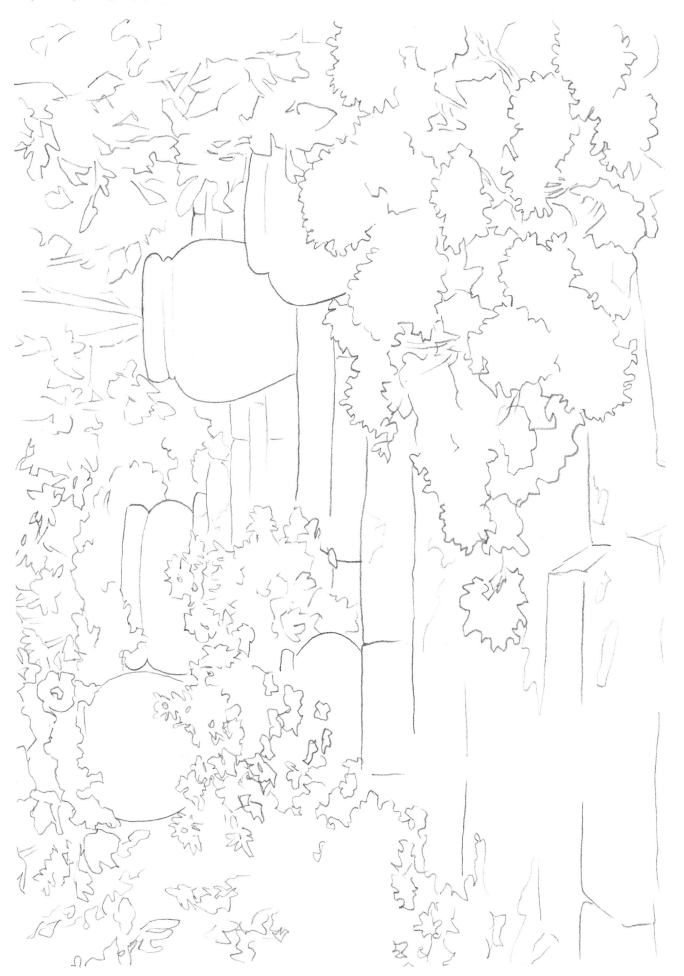

See finished painting on page 60.

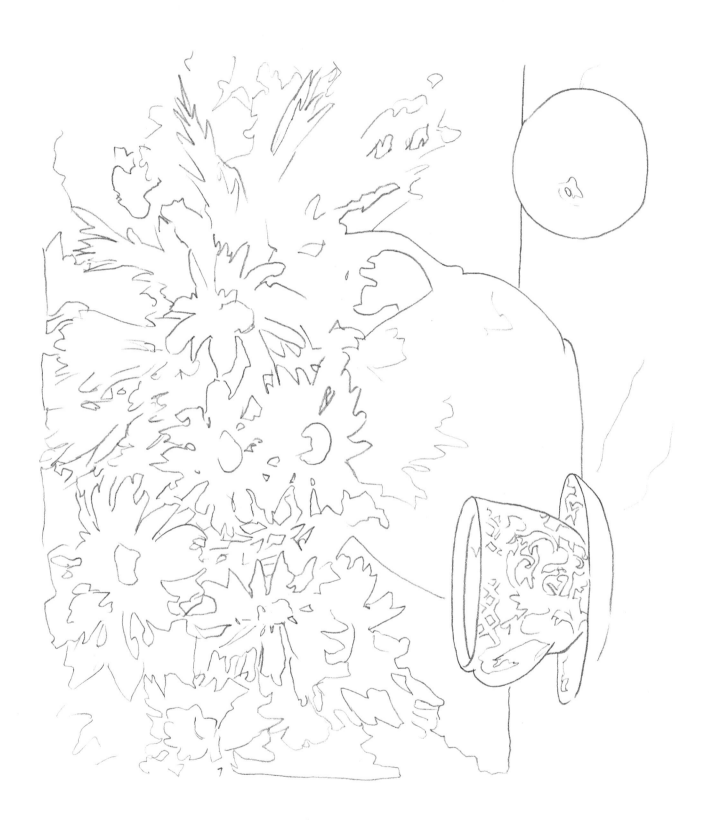

See finished painting on page 61.

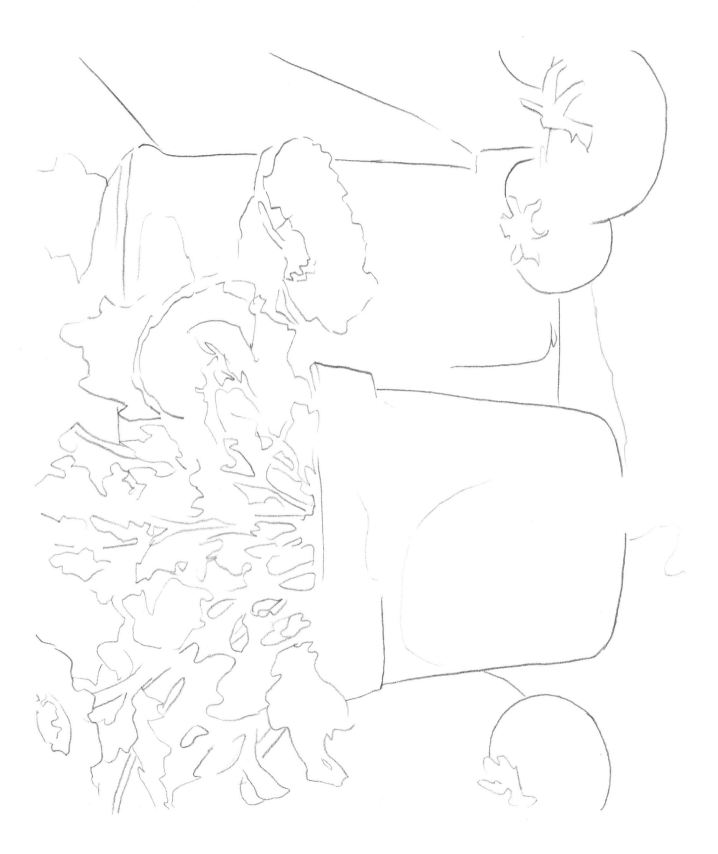

See finished painting on page 62.

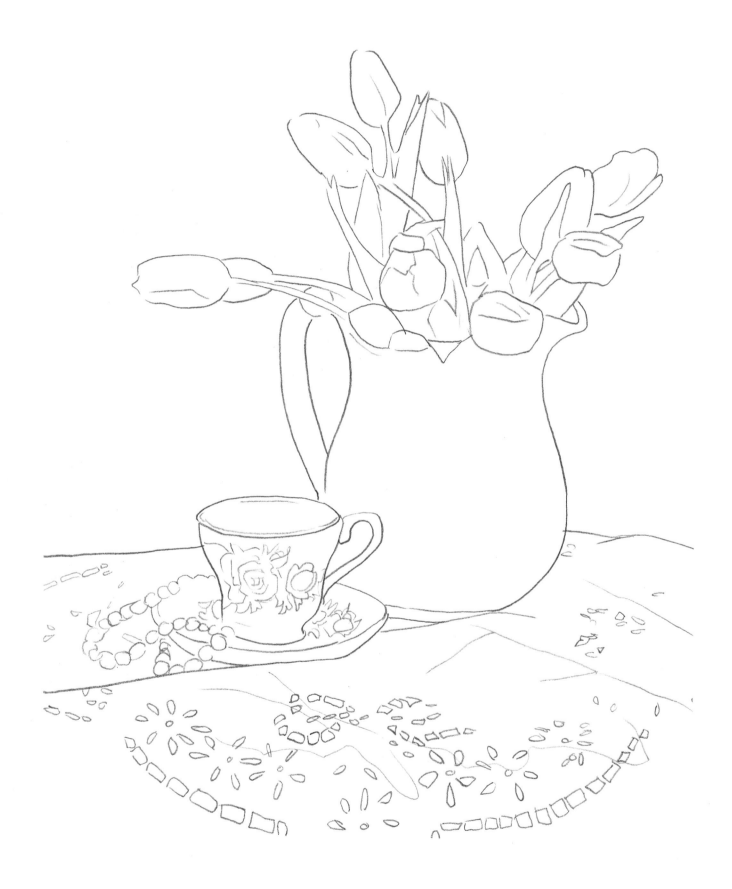

See finished painting on page 63.

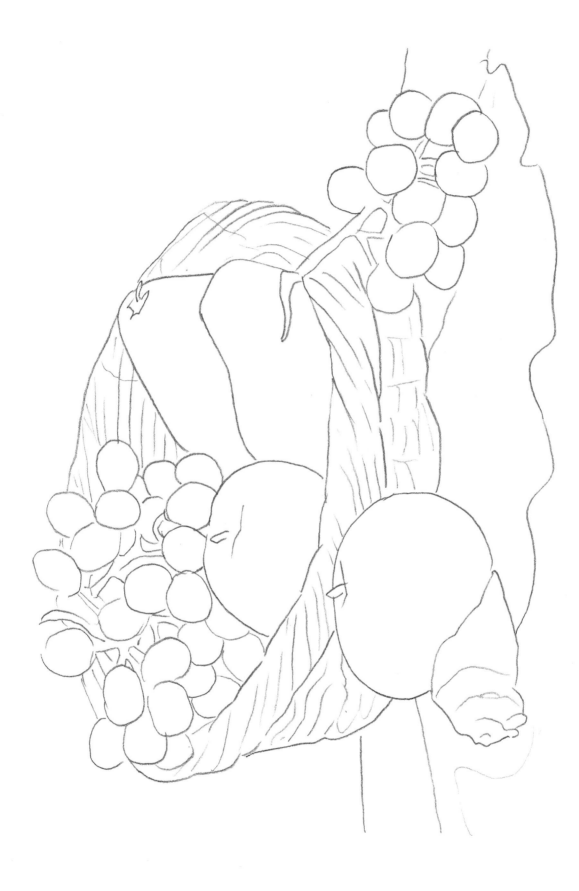

See finished painting on page 64.

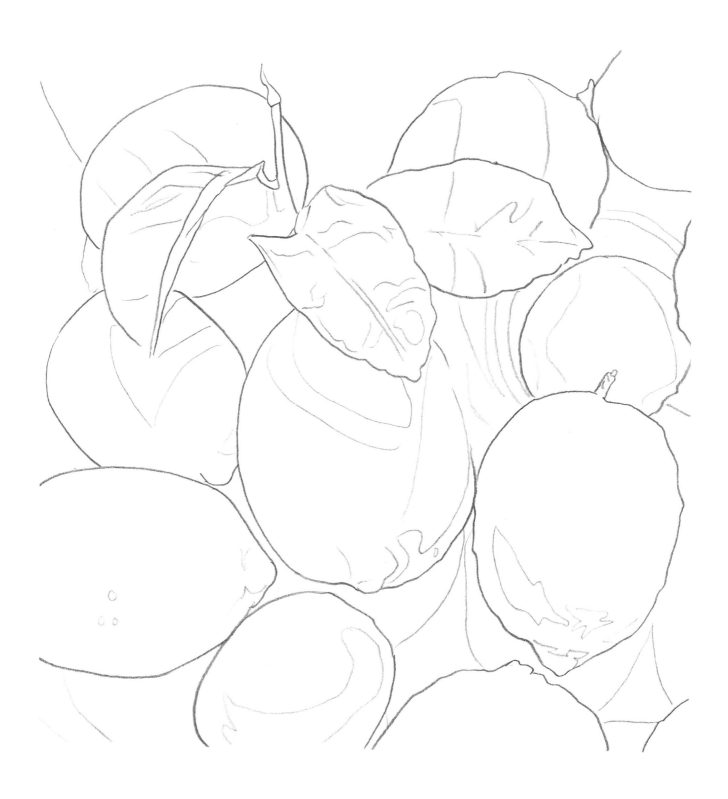

See finished painting on page 65.

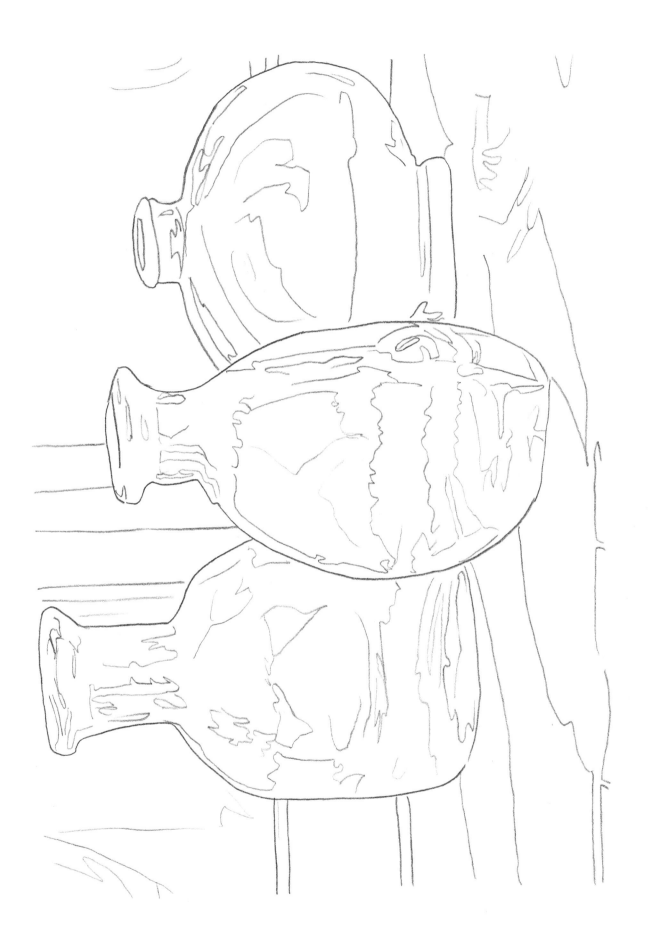

Templates

See finished painting on page 67.

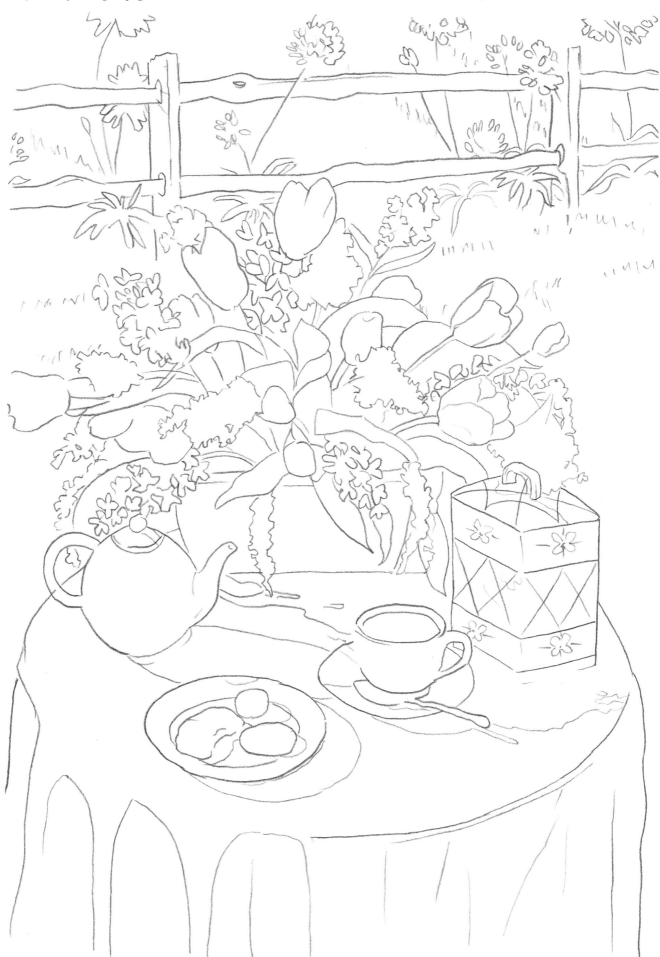

See finished painting on page 68.

See finished painting on page 68.

See finished painting on page 69.

See finished painting on page 70.

See finished painting on page 71.

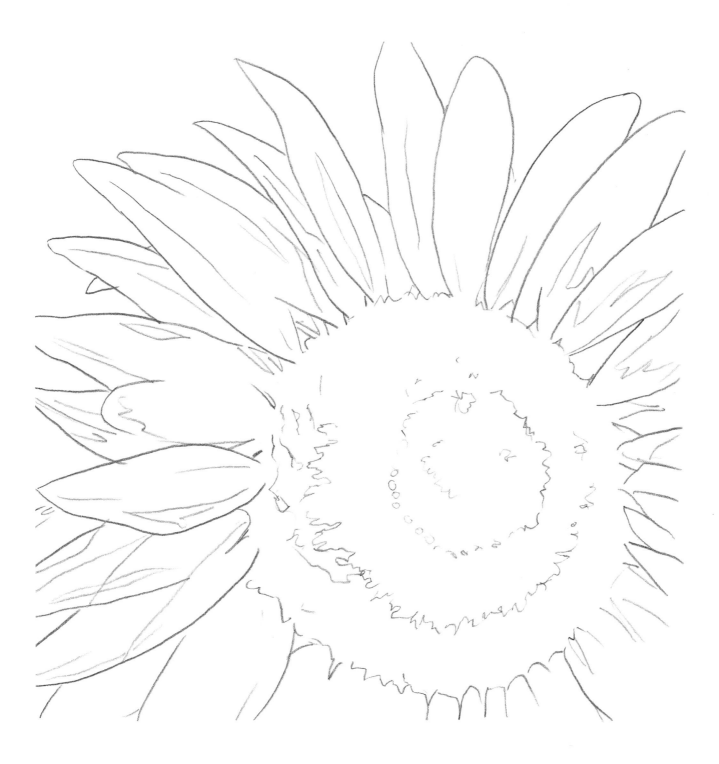

See finished painting on page 71.

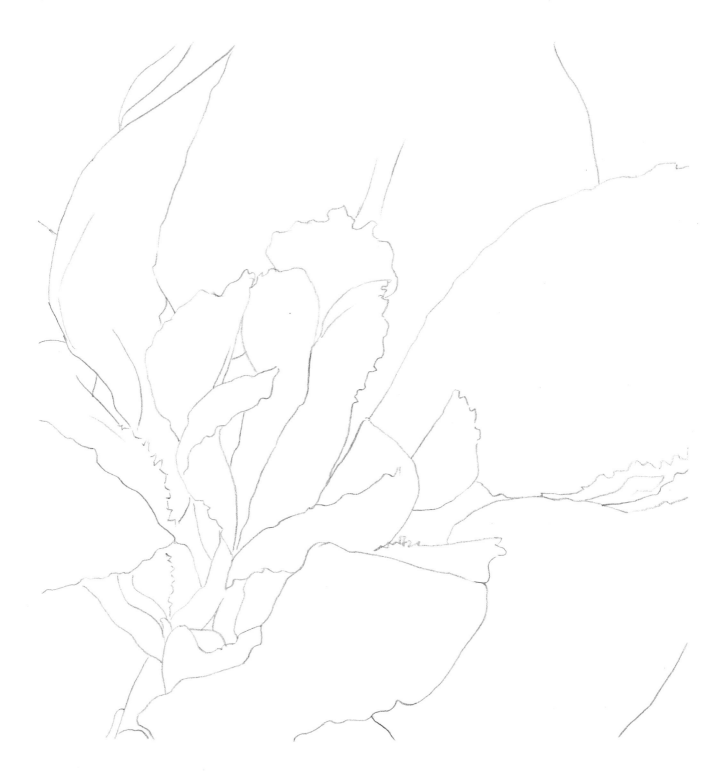

See finished painting on page 72.

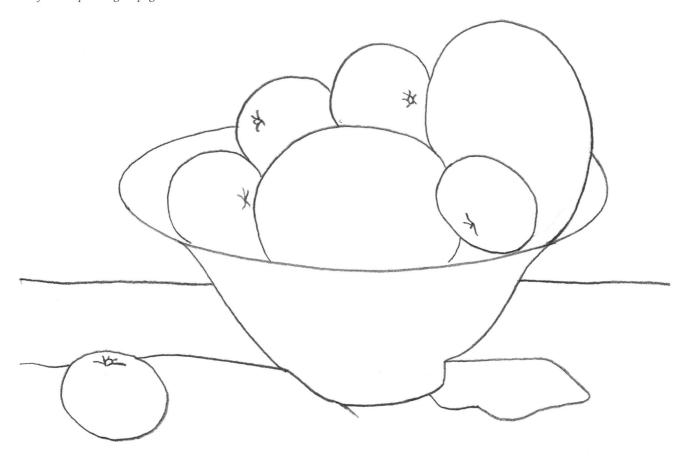

See finished painting on page 73.

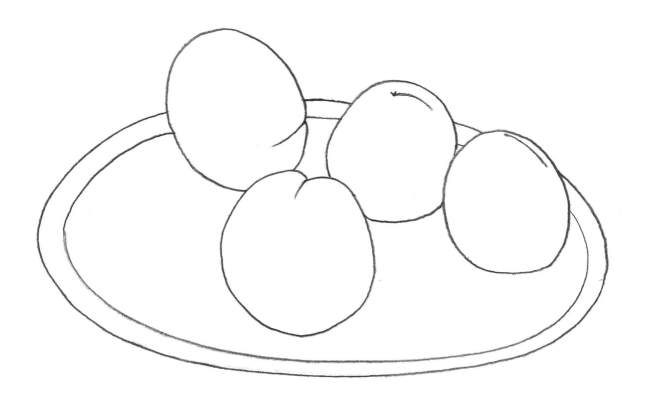

See finished painting on page 77.

See finished painting on page 78.

See finished painting on page 78.

See finished painting on page 79.

See finished painting on page 80.

See finished painting on page 80.

See finished painting on page 81.

See finished painting on page 82.

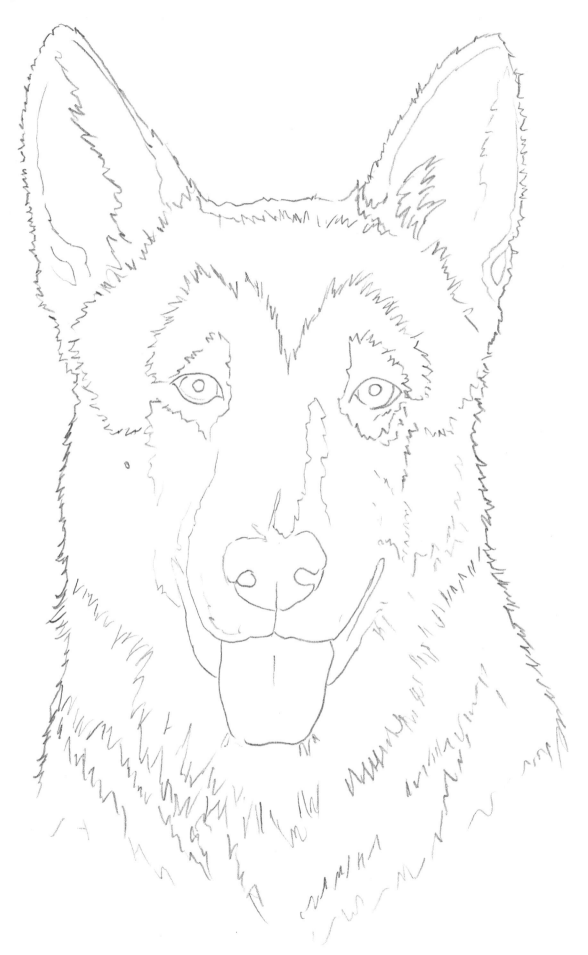

See finished painting on page 83.

See finished painting on page 83.

See finished painting on page 85.

See finished painting on page 86.

See finished painting on page 87.

See finished painting on page 88.